Sculpture in Wood

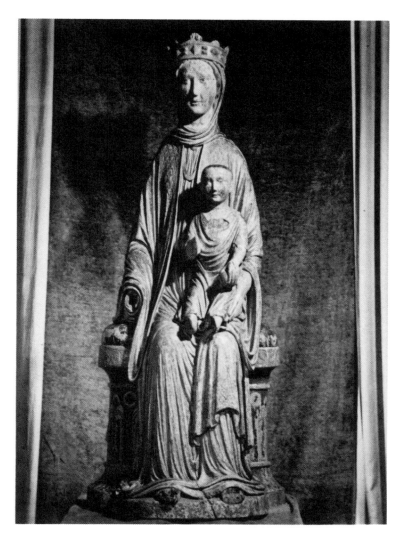

VIRGIN AND CHILD. Île-de-France, early 13th century.
Polychromed oak. 61 inches high.
A beautiful example of Early Gothic cathedral sculpture of Northern France. A characteristic of this period is the highly developed drapery style with deep, undulating folds. Note the grace, serenity and tenderness achieved by the master carver.

The statue was carved from a solid mass of wood, but the hands and toes appear to have been attached to the body by mortise and tenon [see the rectangular hole (mortise) where the wrist and hand were fitted] and by dowelled or pegged joints (see left foot).

Museum of Fine Arts, Boston
William F. Warden Fund

Sculpture in Wood

Jack C. Rich

Dover Publications, Inc., *New York*

Published in Canada by General Publishing Company, Ltd., 30 Lesmill Road, Don Mills, Toronto, Ontario.
Published in the United Kingdom by Constable and Company, Ltd., 3 The Lanchesters, 162–164 Fulham Palace Road, London W6 9ER.

This Dover edition, first published in 1992, is an unabridged and slightly corrected republication (no factual information was altered) of the work originally published by Oxford University Press, Inc., New York, in 1970. The map on pp. xvi and 1 originally appeared on the endpapers.

Manufactured in the United States of America
Dover Publications, Inc., 31 East 2nd Street, Mineola, N.Y. 11501

Library of Congress Cataloging-in-Publication Data

Rich, Jack C., 1914–
 Sculpture in wood / Jack C. Rich.
 p. cm.
 Originally published: New York : Oxford University Press, 1970.
 Includes bibliographical references and index.
 ISBN 0-486-27109-9 (pbk.)
 1. Sculpture—Technique. 2. Wood-carving—Technique. I. Title.
NB1250.R53 1992
731.4′62—dc20 91-44221
 CIP

To Joy

PREFACE

This book is designed to meet the student sculptor's need for a basic modern manual on wood carving. It includes a comprehensive listing of the many varieties of wood which are generally available commercially, describes the tools that are employed and the methods of using them and caring for them.

Wood is but one of the many materials which are readily available throughout the world for three-dimensional artistic expression. However, while wood is one of the gentlest and most beautiful of materials, it is also, paradoxically, one of the most demanding and restricting of the sculptural media. The generally long attenuated mass of the tree and the log cut from it form a rigidly fixed wood mass which limits the potential creator and demands a modification of the basic concept to the realities of the material. The direct carving of wood requires a very clear primary concept, a fairly thorough knowledge of materials and methods of working, and a mastery of one's tools, together with an abundance of labor and patience. Direct wood carving, like direct stone carving, is an analytical process, consisting essentially of carefully removing the superfluous portions of material obscuring the desired final form. While Rodin said that "one must have a consummate sense of technique to hide what one knows", the student should attempt consciously to resist the very strong temptation of becoming overly fascinated with techniques at the possible expense of self-expression.

Grateful acknowledgment and appreciation are due to the many indi-

viduals and organizations who provided me with assistance in the form of photographs and technical information: to Nat Kantor; to Paul Petroff, who made several of the necessary photographs illustrating tool sharpening methods; to Robert C. Storm of William L. Marshall, Ltd., for providing me with veneer samples of exotic hardwoods.

The drawings illustrating the text are by the author, except where otherwise indicated.

J.C.R.

New York
1969

CONTENTS

LIST OF ILLUSTRATIONS

LIST OF FIGURES

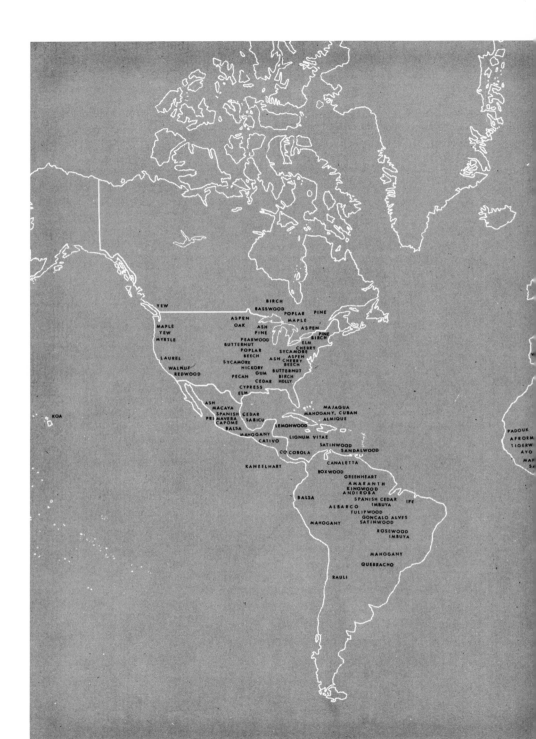

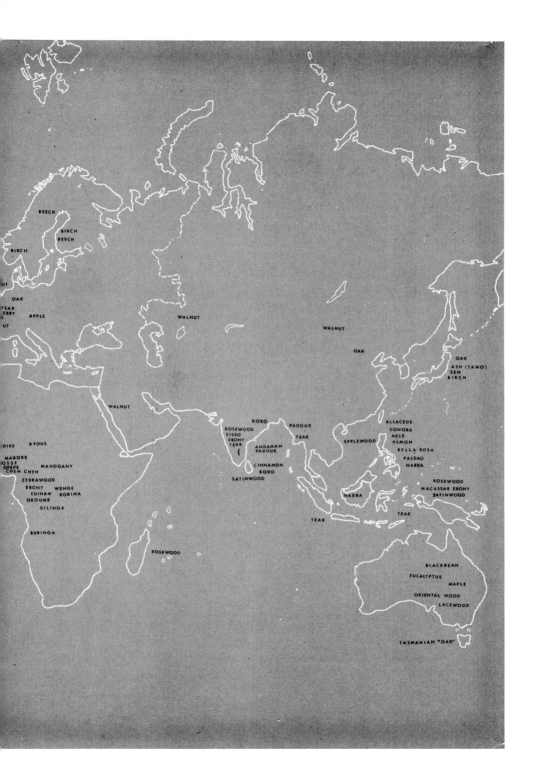

NATURE OF WOOD

Wood has been, and still is, abundant in most parts of the world, and one would naturally expect wood carving to be one of the oldest forms of sculpture. Wood has been used extensively, and by almost every people, as an artistic medium for over 5000 years.

Wood for sculpture is cut from the main portion or trunk of the tree. This consists of the internal heartwood that supplies the structural or supportive strength to the tree, and the surrounding external sapwood that carries water and nutritive chemicals to the branches and leaves.

Heartwood is generally darker and more uniformly colored than sapwood, its hardness and density depending upon the variety. Most types or species of trees have softer sapwood, but there are others which actually have denser sapwood and a softer heartwood.

Sapwood, the living portion of the trunk, is more vulnerable to fungi and insect attack, while the heartwood is harder and more durable because it is composed of dead cells, air, gums, and resins. Since the living protoplasm is gone, it also contains less water than the sapwood.

Physically, wood is fibrous, and for this reason less brittle than stone as a carving material. It is usually quite compact and durable and has a tensile strength that permits the carving of freer forms than are possible with stone. It is comparatively light in weight and not as structurally homogeneous as most of the sculpturally-used metals and stones. The durability of wood is very important to the sculptor. A high degree of resistance to atmospheric

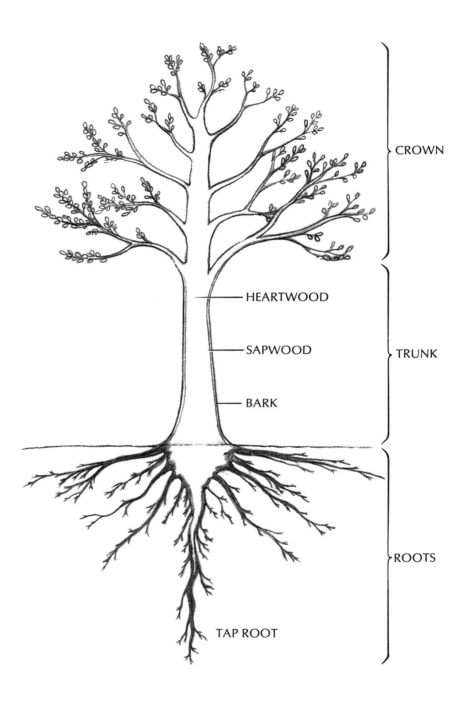

CROWN

HEARTWOOD

SAPWOOD

BARK

TRUNK

ROOTS

TAP ROOT

humidity and to the effects of temperature, together with a resistance to cracking or splitting, is desirable.

Wood is composed of cell structures or fibers, the nature of which determines the hardness or softness of the variety, the ease with which it can be carved, and its porosity. The weight of woods varies almost daily with the moisture content.

"Grain" is a rather broadly used word which actually refers to the direction of the wood cells or fibres. It is also used to describe the light and dark pattern resulting from variations in wood cell or tissue density. The cellular structure of a wood mass is mainly vertical and this is the reason that a length of wood or a log may be most readily split up and down. Cutting a wood mass horizontally or against the grain requires substantially greater effort. There are also horizontal cells which cross the tree and serve to both bind the vertical cells or fibres and to strengthen the wood mass. The ease or difficulty, therefore, with which a wood may be carved is largely determined by the simplicity or complexity of the fibre arrangements.

Both hardwoods and softwoods are used sculpturally. Hardwoods are secured from exogenous, angiosperm trees which have broad flat leaves. These include varieties of ash, beech, elm, maple, oak, and chestnut. The softwoods are secured from gymnosperm trees with narrow resinous leaves, and include cedar, fir, hemlock, pine, and redwood. Generally, the close-grained woods are the hardwoods and these are, naturally, more difficult to work than the softwoods, but they possess the redeeming characteristics of almost invariably being more durable, taking higher polishes, and yielding more sculptural pleasure in working.

Figure 1. Diagram of a living tree. A tree consists of three physical parts: the roots, the trunk, and the crown. The roots physically anchor the living tree in the earth and by means of the fine root endings or root hairs absorb water and minerals in solution from the soil. These are carried by the sap in the sapwood through the trunk and branches to the leaves where they are converted into food for the tree.

The inner bark or phloem carries the food made in the leaves down to nourish the branches, the trunk, and the roots. The outer bark has a protective function and helps to insulate the tree from physical injuries and insect pests. The heartwood portion of the trunk or tree body is inactive and provides support or physical strength.

A tree grows in height and crown spread by the regular addition of new twig growth. The trunk or tree body increases in diameter due to the activity of the cambium, a thin layer of cells, which builds wood tissue internally and bark externally.

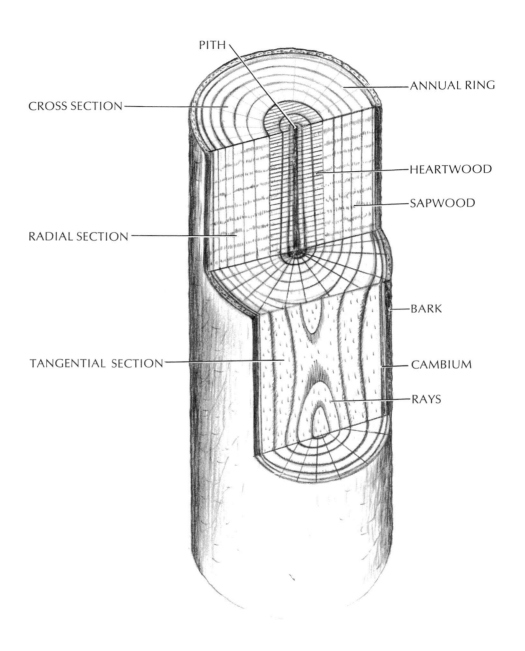

PITH

ANNUAL RING

CROSS SECTION

HEARTWOOD

SAPWOOD

RADIAL SECTION

BARK

TANGENTIAL SECTION

CAMBIUM

RAYS

Figure 2. Diagram of the wood structure of a log.

Ideally the most satisfactory wood would be one which promised to endure indefinitely and not suffer cracking or splitting during the carving process or upon aging.

An extensive variety of domestic and imported woods, varying from very soft to very hard, are available for carving. The domestic woods are usually more economical. Many of the imported wood varieties are fairly costly and some types are only occasionally available, frequently in only small blocks or planks.

Wood suitable for carving is readily available from many possible sources, including cabinet makers, carpentry shops, and the larger lumber yards. Old, solid furniture can be used as a source of well-seasoned wood for carving.

The carver's primary objective should be to secure absolutely sound and well-dried or seasoned wood. He should avoid green unseasoned material and also pieces that are heavily checked or which have obvious visual flaws such as knots or rotted areas.

While it is quite true that many internal defects are revealed only during the carving process, as the outer wood is cut away, there are kinds of wood known to be relatively free of internal defects, whereas others are quite likely to have them.

TOOLS AND EQUIPMENT

Work Bench

A fundamental requirement for satisfactory wood carving is a very sturdy and well-braced work bench or table. To achieve maximum stability the bench may be anchored firmly to the floor or to the wall with right-angled steel brackets.

The bench or table top should be at least 2 inches thick and constructed of heavy seasoned wood. It should also extend 2 to 3 inches beyond the framework so that clamps may be attached, and it should be equipped with a wood vise and a metal vise.

The height of the working surface is most satisfactorily determined by the carver's own height, particularly since a bench or table top that is too low can put unnecessary strain on the back.

The work bench should, ideally, be situated near a window and be well illuminated, because good studio lighting is extremely important for carving. While it is true that a sculptor can work under artificial light, natural overhead lighting, in the form of skylights, is more desirable. It is also important for a wood carver's studio that the air be kept as cool and dry as possible. Each tool should have its place and the studio be kept clean and orderly for maximum efficiency and conservation of time and energy.

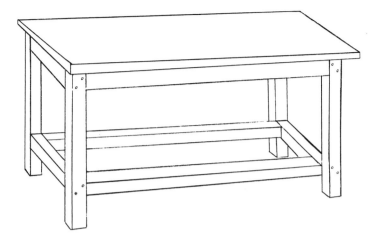

Figure 3. A simple and sturdy work bench frame constructed of 2 x 4 inch legs and braces joined by carriage bolts.

Three-eighth inch plywood panels joined to the braces and legs can be used for the sides and back to achieve additional strength. A ⅜ inch or thicker plywood panel, resting on and joined to the bottom framework will provide substantial shelf space.

Fixing and Gripping Devices

Small- and medium-size pieces of wood are best fixed or anchored mechanically during all aspects of the carving process. There may be an occasional temptation to hold a small block of wood in one hand while carving with a tool held in the other hand, but this procedure is extremely hazardous and should never be followed, even with very dull cutting tools. The carver's hands should *never* be in the path or direction of the cutting instrument. I have seen very deep and very dangerous wounds result from the practice of holding work in one hand while carving with the other.

There are some sculptors who do not make use of special fixing devices to secure very large wood masses while working. While it is true that in some instances the sheer bulk and weight of large blocks of wood may hold them steady during the carving process, it is a recommended precautionary procedure to have the wood block held securely by means of a fixing device.

Medium and large blocks of wood can be held by screwing the mass to a wide, flat wooden base and then clamping or screwing this base to the table or work bench. The sole disadvantage of this method is that the sculptor is

9

generally restricted to carving around the fixed block. Securing the base to a sturdy stand with a revolving top surface would enable the carver to turn the wood mass for carving.

Bench screws, clamps, the carpenter's wooden vise, and the machinist's or metal worker's vise are some of the other devices which are used for anchoring or fixing purposes.

In order to use the carver's bench screw (Figures 4 and 5), a hole must first be drilled through the bench top. The pointed end of the device is then inserted through this hole and screwed into the wood block to be carved. The wing nut is turned for tightening. Some sculptors prefer to use a small block of wood in place of the metal washer.

The coach screw is used in much the same manner as the carver's bench screw to anchor a wood mass. Holes in the bench top must also be drilled before inserting coach screws. They are tightened with a wrench.

"G" clamps are available in several sizes and are very useful fixing devices.

The carpenter's vise has wooden jaws which, in most cases, will not bite into or otherwise mar the wood being worked.

The metal jaws of a machinist's vise will, if tightened firmly, make a squeeze mark or otherwise mar the wood it holds, unless both inner sides of the metal holding jaws are cushioned with insulating pads of firm felt or with broad strips of bodied leather such as plump calfskin, an excellent leather for this purpose. Some wood carvers insulate metal vise jaws with thin strips of wood softer than the wood being carved.

Wood can be chipped, chiseled, chopped, gouged, pared, rasped, sawed, ground down or sanded.

The tools used in wood carving include abraders, cutting instruments, mallets, sharpeners, and miscellaneous finishing materials and tools.

Saws are occasionally used in the preliminary stages of wood carving to remove superfluous masses of wood or waste, prior to beginning the actual carving. The initial work of roughing out may be accomplished with adzes, axes, and chisels or large gouges.

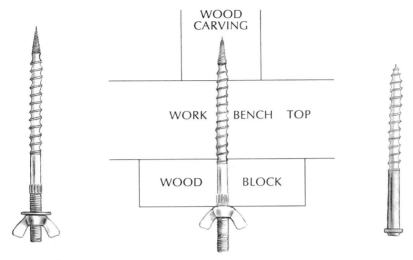

Figure 4. Bench Screw.　Figure 5. Bench Screw in Position.　Figure 6. Coach Screw.

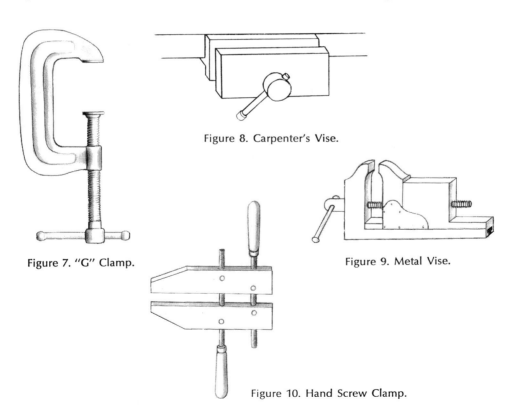

Figure 8. Carpenter's Vise.

Figure 7. "G" Clamp.

Figure 9. Metal Vise.

Figure 10. Hand Screw Clamp.

11

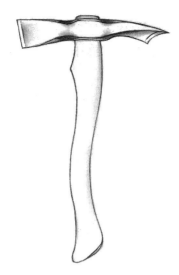

Figure 11. Wood Carving Adze. The steel head has both gouge bit and curved bit cutting edges.

NEWBORN CALF, by Heinz Warneke.
Chestnut wood. Life-size.
Most of the carving of this strong work was accomplished with an ax.

12

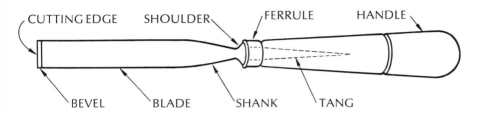

CUTTING EDGE SHOULDER FERRULE HANDLE

BEVEL BLADE SHANK TANG

Figure 12. Wood Carving Chisel.

Chisels

There are hundreds of different shapes and sizes of wood carving tools, but the student should first secure a relatively small working kit, made up of a few fundamental instruments together with one or two mallets, and add to his equipment only as he learns to employ these basic tools. The choicest wood carving tools are made of fine steel and are well tempered and balanced. The sculptor should always purchase the finest possible tools; with the passage of time these will be found to be the most economical. The English wood carving tools enjoy an excellent reputation because of the quality of the steel used, their balancing, and their tempering.

Chisels are carving tools with straight cutting edges, although the term is occasionally used broadly to include gouges. Chisels are available in many sizes and are employed in two ways. The sharp cutting edge cuts into and separates the wood along a specific path, while the bevel and thickness of the chisel serves as a wedge to force the wood apart. The cutting and splitting action may occur simultaneously, or one may rapidly follow the other. The smaller the wedge angle or bevel on the chisel, the easier will be the carving. Low-angled chisels are indicated for carving the softwoods, while tools having higher angles are used for the hardwoods. Because of the fibrous physical nature of wood, all cutting tools should be kept as sharp as possible.

13

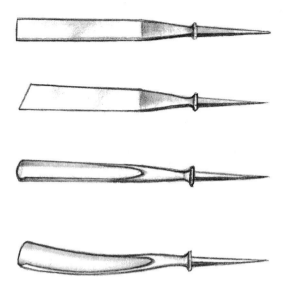

Figure 13. a. Straight or Firmer Chisel. b. Straight Skew or Corner Chisel.
c. Straight Gouge. d. Long Bend Gouge.

Gouges

Gouges are tools with curved or concave cutting edges. The cutting edges vary from semi-circular to almost flat, and there are a multitude of varieties and sizes.

Gouges with their bevel on the outside are called "outside bevel gouges"; those with their bevel on the inside are called "inside bevel gouges". Gouges with bent shanks are used for deep cutting.

The gouge is generally used for blocking out initial masses and for carving the hardwoods. Some sculptors use gouges when cutting across the wood grain.* However, to employ gouges in this manner, the cutting edges must be kept exceedingly sharp. Fairly large instruments, and the mallet, are usually employed during the preliminary roughing-out phases. At this stage, particularly in the carving of very hard woods, such as lignum vitae, it is advisable to wear goggles to protect the eyes from fast-flying chips of wood. As the carving progresses, less curved, smaller gouges and flat chisels are

* Wood is strongest physically along the grain and weakest at right angles to the grain.

14

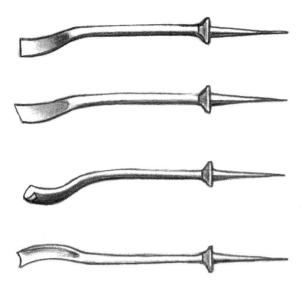

Figure 14. a. Short Bend Chisel. b. Short Bend Right Skew. c. Short Bend or Spoon Gouge.
d. Back Bend Gouge.

frequently used, the tools becoming finer and mallets lighter (see Figure 16). Eventually, for the final, finishing stages, the mallets are often completely discarded and the blows to the cutting tool are supplied by the palm of the hand, or the instruments are directed by simple hand pressure.

Handles

Chisel handles should be of a good quality wood such as well-seasoned maple, because they have to absorb a great deal of punishment from mallet blows. Ash is also frequently used for tool handles and is excellent for this purpose. Boxwood, mahogany, sycamore, and walnut are some of the other woods suitable for handles. The softer varieties of wood are used for smaller cutting tool handles, which should never be struck with a mallet. Leather tipped handles and plastic handles are also available commercially.

Some sculptors prefer to fashion their own handles. In making a handle it is very important to drill the hole which is to take the tang (see Figure 12) in the precise center of the wood mass. In order to achieve a perfect align-

15

Figure 15. Wood Carving Tools. Shapes and Sizes of Some Cutting Edges.

ment of cutting tool and handle, drill the hole in the wood before finally shaping the handle and then gently insert the tang to check the alignment. Slight discrepancies can be eliminated in the final shaping of the handle.

The handle hole should be drilled deep enough to accept all but about ¼ inch of the tang. The tool is then securely fixed in a vise and the handle gently tapped with a mallet until it meets the shoulder of the chisel or gouge. The handle may then be finished with rasps and sandpapers and polished.

Tool handles should be tested manually to make certain that the chisels are securely held. If they are loose, they can be glued and the chisel tang pressed firmly into the open space of the handle. The shoulder should fit compactly against the handle ferrule.

If the handle is square or octagonal in shape, the cutting edge of the chisel should be parallel with one of the flat sides of the handle. Some wood carvers prefer the octagonal handle and feel it to be superior to the round handle because it permits the sculptor to grip more firmly and to hold the tool more securely. The shape, size, and weight of each handle should vary so that the individual tool is well balanced and easily held in the hand.

Many professional wood carvers vary their chisel and gouge handles in terms of size, shape, and even color, so that no two cutting tools have similar handles. This practice saves time during the carving process, since the tools can be easily recognized by their handles and no time is wasted in picking up and selecting the one required.

Mallets

Mallets are indispensable wood carving tools in the early blocking out or "roughing" stages of wood carving.

Several different woods are used for mallets and these are selected for their hardness, physical durability, and weight. The woods must be very well seasoned. Beechwood, hickory, and lignum vitae are the varieties of wood most frequently used. The lighter beechwood mallets are for more delicate carving and for finishing, while the heavier and larger mallets of hickory or lignum vitae are used for large works and for the earlier roughing out stages of wood carving.

In using a mallet it is not necessary to grip the shaft tightly all the time. As the mallet head hits the chisel handle, the grip may be slightly relaxed.

17

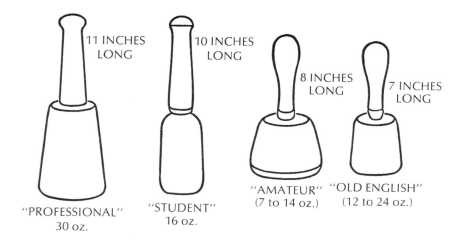

11 INCHES LONG

10 INCHES LONG

8 INCHES LONG

7 INCHES LONG

"AMATEUR" (7 to 14 oz.) "OLD ENGLISH" (12 to 24 oz.)

"PROFESSIONAL" 30 oz.

"STUDENT" 16 oz.

Figure 16. Wood Carving Mallets. Mallets vary in weight according to the wood they are fashioned from. The lightest mallet would be composed of beechwood and the heaviest of lignum vitae. Hickory mallets would lie midway between.

This procedure will minimize the jarring effect of the impact and will prove less fatiguing.

While mallets are important, the experienced wood carver makes great use of just his hands in using his carving instruments. Some wood carvers feel that tools can be controlled more easily, particularly in the later stages of wood carving, by palm impact or hand pushing. They advocate avoiding the use of mallets whenever possible. In the absence of a mallet, the cutting edges of the instrument must be razor sharp. In order to control the cutting instrument, the left hand must both rest on the wood carving and hold the shaft of the cutting tool.

THE CARVING OF WOOD

Wood carving is a difficult branch of sculpture, requiring both experience in sculpture and a knowledge of woods, since each variety of wood and each block or piece presents its individual carving problems. Solid and uniformly bodied blocks of wood, without hard or soft areas or spots, are the best kinds for sculptural use. It is, however, as difficult to determine internal defects within a block of wood as it is to judge internal defects in a stone mass. Some sculptors prefer the core or heartwood, while others like to work with the outer portion of a wood. The *Tight-Rope Dancer* by Chaim Gross illustrates a novel method of using both the lighter outer wood and the heartwood as elements in the design.

While the easily carved softwoods are preferred by many sculptors, a substantial number of wood carvers relish working with the harder, chisel-resisting woods. The student wood carver, however, would be wise to avoid the harder varieties at the beginning. This does not necessarily mean that he should carve only in soft pine; mahogany may be used, but woods such as walnut and lignum vitae are best left until the carver has an adequate knowledge of his tools and carving experience. It is also a good practice for the student to keep his forms compact and rounded and to avoid substantial undercutting and projecting arms and legs.

A wood mass should be studied before carving is begun, as one would study a block of stone or other solid carving substance, to determine the

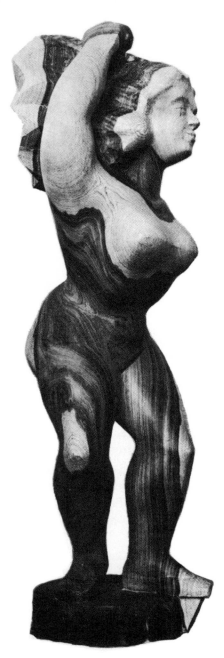

TIGHT-ROPE DANCER, by Chaim Gross. 1933.
Lignum vitae. 30 inches.
A fine example of the utilization of the natural graining of a wood as a vital design element.
Note the light areas of outer wood, which have been retained for their contribution
to the design.

Collection of Mr. and Mrs. Alexander Rittmaster

20

nature of the material and the forms to be carved from it. The design or shape of the forms of a wood carving should bear a direct relationship to the shape and color of the wood mass, the density of the wood variety, and the nature of the graining.

Many wood carvers make a practice of sketching the general form of their design on the wood mass before beginning the carving. This can be done by using ordinary blackboard chalk or charcoal. Ideally, from the point of view of the direct carver, there should be as little waste of material as possible.

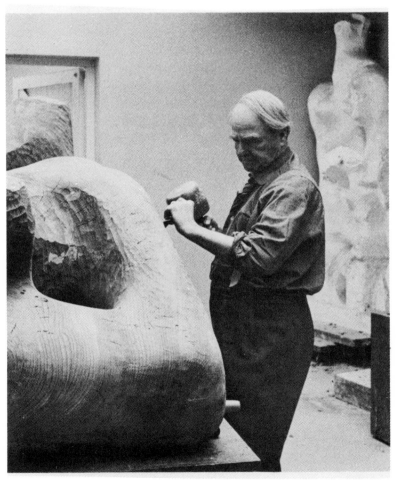

Henry Moore working on RECLINING FIGURE.
1959-1964. Elmwood. 90 inches long.

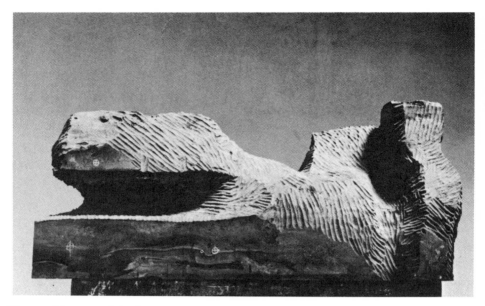

The roughing out of the large masses of RECLINING FIGURE by means of large gouges and heavy wooden mallet. It is important at this stage of the carving process to wear protective goggles.

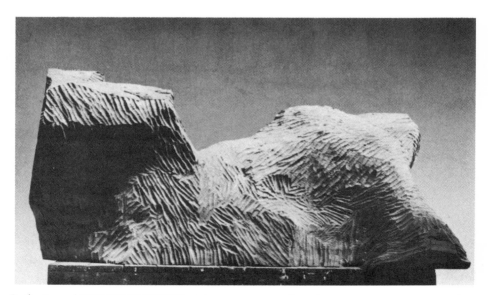

Back view of RECLINING FIGURE at the same stage of carving.

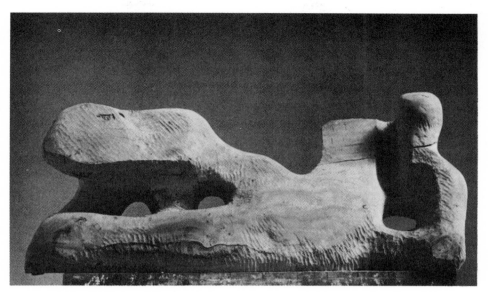

The further development and refinement of forms is achieved by the use of smaller gouges. Note the deep checking.

Back view of carving at the same stage.

The completed work RECLINING FIGURE, by Henry Moore.
1959-1964. Elmwood. 90 inches long.
The fine checks and deeper splits have been filled in and the main masses clarified and
smoothed.

Back view.

The full vitality of concept should be put into the carving and not invested in a preliminary model. Indirect carving, involving a preliminary modeling of the work in clay or wax, as a means of working out three-dimensional problems before beginning the actual carving, is as unhealthy and as undesirable an approach to wood carving as it is to stone sculpture. Pointing by professionals is, unfortunately, also practiced in wood sculpture.

The wood carver will discover in working different varieties of wood that the softwoods frequently require the use of sharper chisels and gouges than do the hardwoods, for if dull cutting edges are used on the softwoods, the wood may become bruised or marred.

MEI KWEI, by Allan Clark. South American Mahogany. 11½ inches high.
A fine example of indirect carving.

The Metropolitan Museum of Art
Rogers Fund, 1927

25

Macassar ebony cut with the grain with a pointed tool. Relatively smooth channels or cuts are achieved when the "length of the tree" or grain is followed. X 12.

Macassar ebony cut against the grain with a pointed tool. Note the very coarse lacerations resulting from cutting against the grain. X 12.

A block of wood should never be cut haphazardly without first considering the direction of the grain and the wood mass in the direction of the cut. The wood carver should also try to avoid "fighting" the wood and cutting against the grain, because carving is easiest when the "length of the tree" or grain is followed, and the wood is cut at an angle. Carving or cutting against the grain frequently proves extremely difficult, requiring much skill and experience and very sharp tools; and the student sculptor may not always enjoy complete control of his tools.

The primary cutting or roughing out of the forms is usually done with large deep gouges. Use as large a gouge and mallet as necessary. Grasp the handle firmly over the tang portion, but not below the ferrule, allowing about 2 inches of the handle to be exposed. Place the thumb along the handle. Holding the handle in this manner will enable the carver to control and to guide the cutting tool, and will also minimize the possibility of striking the hand with the mallet. Goggles should be worn at this stage to protect the eyes from flying chips. Keep your hands behind the cutting tool to avoid injury.

The gouge, held at an angle of about 45°, is driven into the wood to a maximum depth of about half an inch, cutting with the grain. Maintain sufficient grasp of the handle to keep this depth, while leveling off the gouge. The initial angle can vary to about 90° in the beginning stages of carving, when the action of the gouge can be almost likened to a chopping action. The objective of the initial cuts is to *sever the grain*.

Cut to about an inch of the objective and remove the gouge. Reverse the direction of the gouge and cut back to remove the chip. Never attempt to use a gouge as a lever to pry a portion of wood loose.

Another approach is to think in terms of three fairly full or strong mallet blows for each series of cuts. The initial impact of the mallet on the gouge should lodge the instrument in the wood mass. The angle of the cutting tool should be reduced for the second mallet blow, which will drive the gouge forward, cutting through the wood mass. With the third and final blow the gouge is pointed upwards in a scooping action to remove the wood chip.

In the initial roughing-out phases, be very careful not to drive the gouge too deeply into the wood or the tool may become firmly wedged in the wood mass and may fracture as attempts are made to free it. Proceed carefully and slowly: you can remove wood but not replace it. The objective of this stage of wood carving, utilizing fairly large tools, is to achieve a broad blocking out of the masses.

To minimize the possibility of checking while carving a block of wood, paint each freshly carved area, at the termination of the day's carving, with a thin coating of shellac.

Smaller gouges may now be introduced, as the form evolves. The less curved or flatter and smaller or narrower gouges are now used to work over the entire wood surface, gradually refining the forms and bringing the carving closer to completion.

Smaller mallets should also be used at this stage and then gradually be supplanted by blows delivered to the cutting instrument with the fist or palm of the hand.

As the rough forms are refined and the final surfaces are approached, carve more carefully and slowly.

The original fairly acute angles of gouge to wood surface are gradually reduced as smaller cutting tools are employed. Smaller and smaller chips will now be removed and a smoother wood carving will evolve. As the carving now progresses the gouges should be held almost parallel to the wood surfaces.

When the forms have been completely developed by carving you will arrive at the point where any cutting instrument will tend to remove too much wood, and in order to develop the surfaces any further it will be necessary to abrade rather than cut.

Abrading Tools

There are a variety of different types of steel abrading instruments. These include small rasps and rifflers, large true rasps, and files and steel scrapers.

Files are fairly gross hardened-steel hand tools with sharp metal cutting ridges or teeth, which are used for shaping larger masses or forms. They are available in convex, flat, and round shapes, varying in their abrading surfaces from very coarse to very fine.

Rasps are generally smaller, specially shaped steel hand-filing tools with cutting prominences or points. They are sometimes referred to as carving files and are also available in very coarse abrading surfaces to very fine. The medium and finer teethed instruments will be found to be the most valuable. The coarser, larger teethed rasps are somewhat difficult to use and are physically exhausting.

Rifflers are, technically, smaller curved files or rasps. They are also made of very fine steel and are used for filing or shaping delicate contours or forms and for working in cavities or depressions. Both ends of rifflers are working or abrading ends joined together by the metal shaft or handle.

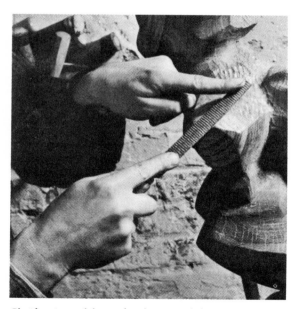

Clarification of forms by the use of the rasp.

Rasps and rifflers are also used on metal, plaster, and stone carvings. Files are usually employed first, followed by rasps or rifflers.

The logical procedure in using abraders is essentially the same as that observed with the cutting tools. Start with the coarse or larger instruments which will remove wood more rapidly and procede gradually to the finer abraders.

All abrading tools should be used with great care, particularly on the softer varieties of wood, because the cutting edges or teeth tend to bite deeply into the wood mass and to mar the surface with ugly scratches. The coarser tools will, naturally, bite deeper than the finer tools. Test each tool before using it on the wood carving by first applying it to a smooth piece of the same wood.

It is a wise procedure to save some of the wood dust resulting from the application of the abrading tools for use in filling in small cracks when the carving is completed.

Subsequent to the use of files, rasps, and rifflers, the final surface finishing or smoothing may be done with metal scrapers, followed, when deemed necessary, by sandpapering.

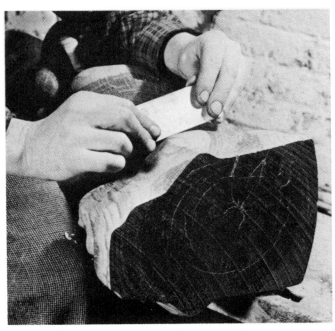

Smoothing the surface of a wood carving with a scraper.

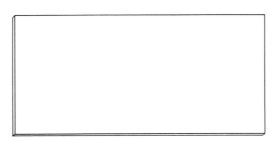

Figure 17. Scraper.

Figure 18. Turned Edge or Cutting Burr on Scraper.

Scrapers

Scrapers are flat, generally rectangular, steel hand tools, which vary slightly in dimensions (see Figure 17). A 3- x 6-inch scraper is a satisfactory size. They are used for smoothing wood surfaces so that little or no subsequent sandpapering is required. Scrapers can be secured from local hardware stores, or an excellent scraper can be made from a flat piece of thin steel. Clamp the piece of steel securely in a vise and smooth or level the entire length of the top edge with a fine mill file. Keep this edge perfectly flat, squared off at right angles to the blade body. With a burnishing tool or a smooth piece of steel such as the side of a chisel blade, rub the scraping edge of the scraper being fashioned, with considerable pressure, to produce a burr or turned edge (see Figure 18). This edge is the part of the tool that will do the cutting or smoothing of the wood surface.

Scrapers are generally held at almost right angles to the wood surface and drawn toward the body, while exerting a mild pressure. Always scrape with the grain of the wood. The corners of the scraper can be used for detail and for smoothing depressed areas of carvings.

As this finishing tool is used on a wood carving, the full color and beauty of graining of the wood will be revealed.

Sandpaper

There are three types of abrasives used in making sandpapers for wood finishing purposes.

Aluminum oxide, a product of the electric furnace, is the toughest cutting abrasive and the longest wearing. Flint, a natural form of quartz, which is

30

used to make less expensive and less durable papers, and garnet, a natural semiprecious stone, are other abrasives.

Abrasive papers are now graded by descriptive terms according to the size of the grit, varying from Very Coarse to Very Fine. These are generally available in belts, discs, rolls, and sheets.

In using sandpaper for finishing purposes, always begin by using a coarser paper and follow with the finer papers, ending with the abrasive polishing papers. In sandpapering the softwoods start with Fine and finish the sanding with Extra Fine. To achieve an extremely smooth final finish on softwoods, dampen the wood surface slightly with a sponge moistened with clean water. Permit this to dry thoroughly and then sandpaper the surface once more with Very Fine aluminum oxide paper. The application of water to the wood carving will cause the surface fibres to swell and the final sanding will remove these fine fibres or fuzz, resulting in a satin smoothness. The procedure will also minimize grain raising when stains are applied.

Never sandpaper across the grain, but always with the wood grain, to avoid scratches on the wood surface. Sanding across the wood grain, even with the finest papers, will result in scratches.

Sandpaper should not be torn. Place the sheet face down and cut the back surface of the sandpaper with a knife to the desired dimensions.

The use of sandpaper should be kept to a minimum because much of the appearance of a wood carving rests in the clean, sharp chisel and gouge cuts, and these are almost invariably dulled or actually erased by the overuse or misuse of sandpaper. If abrasive papers are used for finishing a wood carving they should be applied very carefully and conservatively, to avoid a possible loss of detail and modeling.

It is a good practice to *forgo the use of sandpaper until all of the carving has been completed,* because small particles of abrasive grit may become embedded in the wood, and cutting tools used subsequently on these areas will quickly lose their sharpness.

Sandpaper can be used over broad surfaces mounted on a hand holder, wrapped around a small block of wood, or even wrapped around a finger.

The harder varieties of wood, such as ebony, lignum vitae, rosewood, and teak, have a natural wax content and to finish the surfaces of carvings in these woods fine abrasive papers are used to sand the surfaces smooth. The carving is then rubbed well with a clean cloth.

Some sculptors utilize an agate burnisher to finish hardwood surfaces. The burnishing compacts or presses down the surface fibres and results in

a good polish. Hardwoods can also be finished by rubbing the wood carving with shavings or small chips of identical wood.

After the sanding has been completed, any cracks in the wood carving may be filled in with stick shellac of the same color as the wood (see also *Preservation*).

Sharpening

Many sculptors observe the commendable practice of continually sharpening their carving tools while they are working, and the importance of keeping tools perfectly sharpened at all times cannot be overemphasized. If sharpening is done properly, it will yield a better cutting instrument and one that will require sharpening less frequently.

The process of sharpening consists of three phases or stages:
1. The primary shaping of the tool by rough grinding to its required front curve or straight edge.
2. The sharpening of the instrument by rubbing on oilstones or whetting.
3. The final finishing of the cutting edge to its maximum keenness by stropping on leather or on a soft wood block.

Grindstones, oilstones, slipstones, lubricating oil, and a leather strop are required materials for sharpening wood carving tools.

The primary rough edge shaping is generally accomplished by holding the cutting edge of the tool at right angles to an old-fashioned grindstone or grinding wheel. (The cutting instrument may also be shaped by rubbing on an oilstone or whetting on a whetstone, although both these procedures require more energy and time.) Grindstones enable the wood carver to cut his steel tools rapidly and they also result in a very desirable concave or *hollow ground* bevel. This concavity gives a longer lasting cutting edge and

a b c

Figure 19. Chisel Bevels. a. The length of a good chisel bevel is about twice the thickness of the chisel.　b. This bevel is a bit too long resulting in a cutting edge which nicks easily and becomes dull quickly. However, it may be desired for use in carving softwoods. c. This bevel is much too blunt, making carving quite difficult.

32

Figure 20. Shaped Slips for Sharpening Wood Carving Tools. The stones are shaped to fit the many curves and angles of the cutting edges.

also yields a thinner cutting edge, which will penetrate the wood mass more rapidly.

Extreme care must be observed, however, in using grindstones to avoid possible loss of tool temper due to overheating of the tool edge. Tools should be ground very carefully and slowly with adequate lubrication and without excessive pressure of the tool against the grindstone. While grinding, the chisel should be cooled frequently by dipping the edge into cold water to prevent burning of the steel.

The grinding surface of the wheel, as it revolves, should turn away from the tool being shaped or sharpened.

Oilstones. There are two types of oilstones: natural stones and synthetic or manufactured varieties.

Arkansas, a fine white stone, and the harder Washita stones are examples of the natural stones that yield a very fine cutting edge but are slower acting than the synthetic stones. They are usually used for finishing tools prior to stropping.

The synthetic stone surfaces are much harder than the natural stones and should be used in the initial sharpening stages, when it is desired to wear metal off rapidly. Synthetic sharpening stones of aluminum oxide or silicon carbide are available in different abrasive grades from the very fine to medium to very coarse. Many of the synthetic sharpening stones are made with a coarse abrading surface on one side and a finer surface on the other.

Slipstones are sharpening stones manufactured of the same materials as oilstones, but they are shaped specifically for sharpening the inner surfaces of fluters, gouges, parting tools, and veiners.

Whetstones are sharpening stones that are lubricated with water instead of oil.

33

Oilstones should always be kept flat. When a surface becomes worn or uneven from use it can be restored by rubbing it even on a sheet of fairly coarse emery cloth which has been placed on a perfectly flat surface, such as a piece of plate glass. An uneven oilstone may also be restored by rubbing the uneven surface on a sheet of plate glass lubricated with a paste of silicon carbide powder of about 80 grit, mixed with water.

Coarse-grained stones may be used to sharpen very dull or nicked tools. The finer oilstones are generally used afterwards for sharpening flat chisels or gouges to the fine edges required for wood carving. The flat surface of the oilstone is necessary to achieve the final sharp and durable cutting edge.

Never use an oilstone dry or the surface will clog and glaze as the microscopic steel particles worn from the tool being sharpened are forced into the stone surface. A few drops of machine oil or fine Pike oil placed on the clean stone will serve as a lubricant. Avoid the use of heavy oils and greases, particularly linseed oil, which will harden as it oxidizes and clog the stone surface.

Flat chisels should be ground or sharpened with the edge of the cutting tool worked against the flat sharpening stone, except when stropping on leather or when sharpening the inner surfaces of a gouge or similar concave cutting edge with a slipstone. The practice of sharpening against the edge minimizes so-called "wire-edge" or burr. The reverse side of the chisel is best kept perfectly flat.

Sharpening a chisel.

The cutting edges of chisels should always be kept even and straight. If the edge of a chisel becomes chipped, the nicks can be ground off on a grindstone, holding the cutting edge at a very slight angle or at right angles to the wheel, which should turn away from the tool edge.

It is very important to remove nicks, because even a finely nicked cutting edge can mar softwoods. If a grindstone is not available, a synthetic oilstone should be used, although this may mean markedly slower sharpening.

After the nicks have been removed, a new bevel must be shaped by grinding and a new cutting edge also formed. The cutting edge can be resharpened on an oilstone with the chisel held at an angle of about 20°.

In sharpening a chisel on an oilstone, the stone should first be cleaned and then lubricated with sufficient oil to wet the surface. The chisel should be held with the beveled edge lying flat on the stone and, when this is at the correct angle, the tool should be firmly grasped with both hands and then moved back and forth, along the entire length of the stone. As the chisel is moved away, a gentle pressure should be exerted, and as it is drawn toward the body, the pressure should be eased to avoid wearing a groove in the oilstone. A gentle, controlled, and even spiral or oval motion, utilizing a large area of the oilstone is recommended.

Most wood carving is accomplished by means of gouges and it is very important that these be kept properly sharpened for satisfactory perform- ance. The cutting action of the gouge is essentially one of scooping. The

Sharpening the Outside Bevel of a Gouge on an Oilstone.

Sharpening the Inside Bevel and Removing Burr.

gouge cuts into the wood because the cutting edge of the tool is ground with a bevel on the underside. This bevel must be kept curved and the original shape retained. U gouges should be cut back slightly or rounded at the curve ends to both reduce the wood resistance in carving and to also reduce the metal strain in the carving process.

With gouges, the sharpening method is generally reversed. Specially shaped slipstones (see Figure 20) are employed and the stone is rubbed against the gouge.*

Another method consists of first lubricating the oilstone. The gouge is then grasped firmly in the right hand and the fingers of the left hand are placed flat on the gouge shaft. The gouge is then moved very slowly from side to side on the stationary oilstone, with an even finger pressure while maintaining a low angle of cutting bevel to stone surface. Since the bevel should follow the tool curve, the right wrist is slowly turned or twisted to guarantee that the entire cutting edge and bevel will be uniformly in contact with or exposed to the abrasive stone surface as it is passed back and forth over the oilstone. When the edges are exposed to the stone, be very careful not to abrade the outside corners. Examine the bevel and the cutting edge visually frequently to guarantee a uniform sharpening of each tool.

* These are specially shaped abrasive stones and are regarded as the very finest sharpening devices for all straight or bent gouges.

Sharpening the Outside Bevel of a Gouge
on a Slipstone.

In the event that a wire edge or burr has formed on the inner edge surface, this may be removed with a rounded-edge slipstone that fits the inside gouge curve. The slipstone is held in the hand and rubbed slowly back and forth, while held flat, against the inside of the groove. Inside-bevel gouges are whetted on stones with rounded edges.

The method which is generally employed, but which may prove to be somewhat difficult for a beginner to master, consists of first lubricating or oiling a clean slip. The gouge to be sharpened is then grasped securely in the left hand with the elbow bent and the gouge handle resting against the side of the body. The inner surface of the gouge curve is kept facing the sculptor. The slip is then grasped in the right hand, between the thumb and the forefinger and rubbed in an up and down movement against the gouge bevel, while, simultaneously, the metal gouge shaft is rolled or slowly rotated in the left hand to guarantee that the cutting edge is completely and uniformly exposed to the abrasive stone.

Softer slips, such as the Burma slip, cut quickly and are used to initially sharpen the gouge, after which hard Arkansas or Ozark slips are used for the final finishing or honing.

Chisels and gouges should be wiped clean with an oily rag before they are set aside to prevent the formation of rust.

When not in use, sharpening stones should be stored in a cool, moist area, after first cleaning the surfaces with clean cotton cloth to remove any

dirty oil. Heat will cause the oil to form a gummy residue on the stone surface. A gummy or glazed stone surface should be washed with a dry cleaning solvent or with ammonia. If this treatment is not adequate, scour the surface with fine aluminum oxide abrasive cloth.

In all cases, the length of the bevels on the cutting ends of carving tools should be retained, and particular care should be exercised during the sharpening process not to shorten the bevel. Some sculptors determine the bevel angles of both chisels and gouges according to the nature of the wood to be carved. The softwoods permit the use of long bevels at acute angles that would not prove practical for carving the hardwoods. It should be remembered that steep or very high bevels can slow the carving process markedly (see Figure 19).

After the wire edge has been removed the gouge is ready for the final stropping and use. After sharpening, to achieve very keen, razor sharp cutting edges and to remove wire edge or burr, it is advisable to strop the tool carefully on both sides, about a dozen times on a leather strop similar to that used for sharpening razors, or on a soft wood block.* Fine abrasives, such as pumice or putty powder, can be used on the leather strop. To finish the inside surface of gouges, small pieces of leather can be used, wrapped around a slipstone or one's finger.

Before carving, all recently sharpened cutting tools should be wiped clean to remove *all* vestiges of lubricating oil, because the oil might deeply stain the wood to be carved.

Care of Tools

Wood carving tools should be kept clean and as sharp as razors. When tools are not being used they are best protected by being lightly oiled to minimize oxidation or rusting, and they should be kept in a dry place. If possible, they should be wrapped in soft, clean cloths before they are stored away. Many wood carvers hang their tools on wall racks to protect the cutting edges when the instruments are not in active use.

Rust can be treated when it first appears by rubbing the oxidized area with a soft, clean cloth moistened with a small quantity of oil. The tool may then be set aside, and after a few days it can be rubbed with a finely powdered, unslaked lime.

* An old, but excellent method of lubricating a leather strop consists of burning a piece of plain cotton string and, after extinguishing the flame, dropping the ash on the strop.

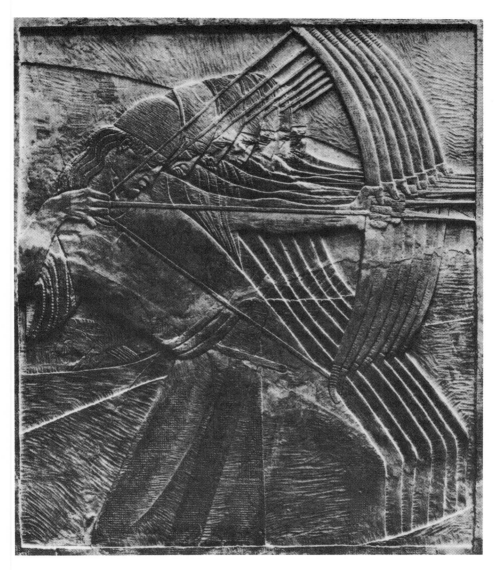

THE ARCHERS OF DOMORGOI, by Ivan Meštrović. Nova Europa. Zagreb. 1933.
An outstanding contemporary wood relief. Note how the illusion of depth and perspective
are achieved by the very delicate recession of the forms. By repetition, Meštrović has
succeeded in creating a fine design with great dramatic power.

Carving a Relief Panel

The procedure employed by many wood carvers in fashioning panel reliefs consist of first making an outline drawing or sketch upon the clean wood surface, after which the sculptor proceeds to cut away the background. The uncarved portions will then represent the highest planes of the relief.

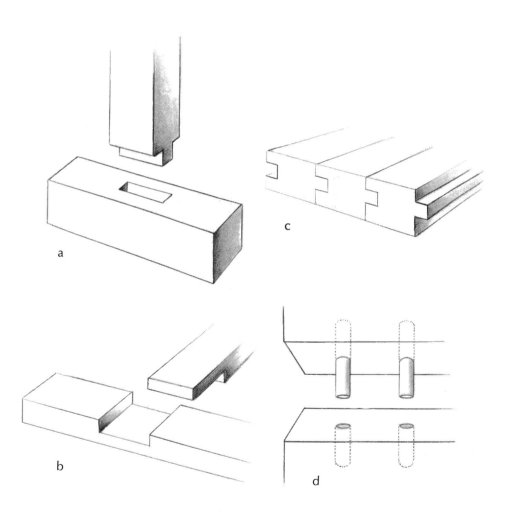

Figure 21. a. Mortise-Tenton Joint. b. Halved Joint or Middle Lap.
c. Tongue and Groove or Housed Joint. d. Dowel Joint.

Clamps are often required in carving relief panels. The panel is generally placed flat upon the worktable with its bottom edge lined up flush with the table edge. Insulated metal or wooden clamps are then applied to grip and hold the wood panel securely to the table surface while the carving progresses.

Reliefs should be carved very carefully and slowly. To guarantee even and clean carving, it is very important that sharp instruments be used.

Joining Wood Masses

A sculptor may occasionally be confronted with the problem of not being able to secure a wood mass sufficiently large for a specific work. By laminating pieces of sections of wood, the artist can build up substantially larger wood masses, the proportions of which might not be available or even actually exist. The procedure is also more economical than purchasing a large solid wood mass.

While lamination gives the wood carver a substantially greater range of sculptural expression, some direct carvers feel that the process of joining pieces of wood together to achieve longer or wider masses, or both, is a violation of material. They believe that the accidental mass or shape of blocks of wood or logs as they come into the sculptor's possession should be accepted, respected, and adhered to in determining the concept and the eventual carving.

The practice of joining pieces of wood together for sculptural purposes is not a contemporary development, but one that dates back to the early Egyptians. There are Renaissance and also earlier European examples extant of works carved from masses made of smaller units joined carefully together.

Regardless of the method of combination employed, it is very important to prepare the surfaces to be joined very carefully so that they fit perfectly. The wood surfaces must also be dry and absolutely clean. It is also important to try to match the grains as closely as possible and to make sure the grain runs in just one direction. The pieces or sections should be carefully cemented and, if desired, also dowelled and then subjected to adequate binding pressure until the adhesive has set thoroughly.

One of the very important advantages of lamination is the fact that when it is properly done it markedly reduces the possibility of deep checking or splitting. And as it is practiced by sculptors such as Leonard Baskin, with a

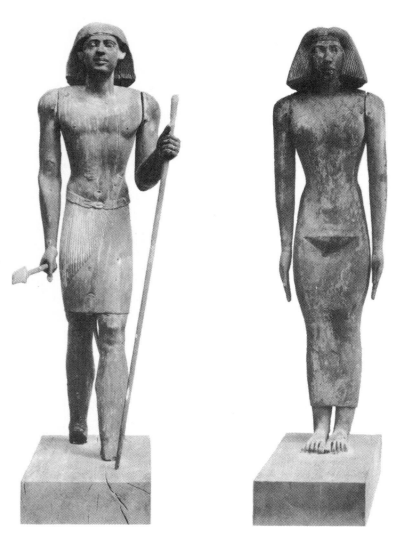

THE PROVINCE ADMINISTRATOR, MITRY AND HIS WIFE.
From his tomb at Saqqara. Early Dynasty V, c.2450 B.C.
Painted wood. About 58¼ inches high and 52¼ inches high.
Large, solid Egyptian wood carvings are rare because wood was very scarce in ancient Egypt and frequently had to be imported from other countries.

Some fairly small wood carvings were made with as many as a dozen pieces of wood joined together to form a larger mass.

The arms and sometimes other parts in many wood carvings were fashioned from separate pieces of wood and joined to the body by dowels or mortise-and-tenon joints.

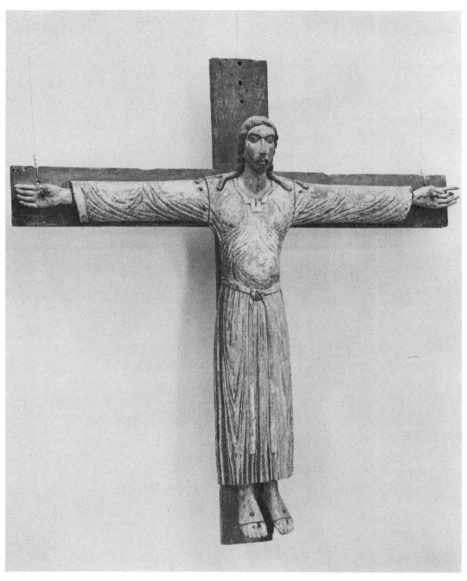

CRUCIFIX. North Italian, XII-early XIII Century. From a monastery near Treviso.
Inspired by the "Volto Santo" at Lucca. Painted wood. 75½ inches high, 81 inches wide.
It was customary in medieval times, particularly in fashioning large wood carvings, to join
the arms to the body mass. The arms, hands, and toes, in this particular piece, have been
joined to the body.

The Metropolitan Museum of Art
Fletcher Fund, 1947

43

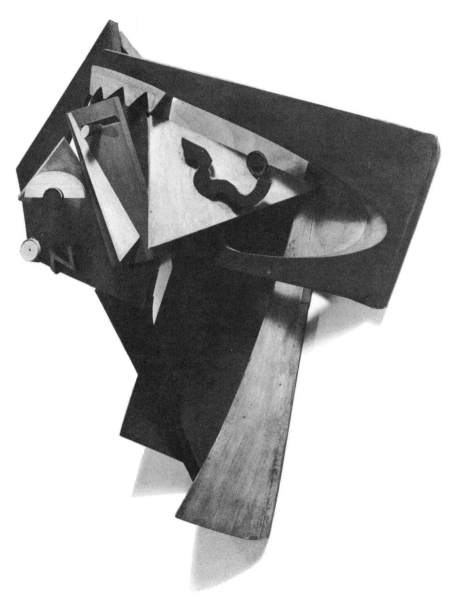

HEAD, by Henri Laurens. 1918. A wood construction, subsequently painted. 20 inches high.

Museum of Modern Art
Van Gogh Purchase Fund

prior conception, it requires less actual carving than does a single mass.

Glues. There are several types of glues which may be used for joining wood together.

Animal glues are made from bones and hides and are available in many forms such as chips, flakes, ground, sheets, and as a prepared liquid. We have evidence of the use of animal glue by the Egyptians dating back to about 1400 B.C. To prepare animal glue, soak the glue in sufficient cold water to cover the dry material, in a gluepot or double boiler, for from 2 to 10 or 12 hours, depending on the dry form used: chip, flake, ground, or sheet. Before using, heat the partially dissolved glue in the gluepot or double boiler to about 140° F., but below 150° F., until it has thoroughly dissolved. Temperatures above this will weaken or destroy the strength of the adhesive. Unused glue can be remelted for use at another time, but do not mix new and old batches of glue together.

Bone glue tends to absorb moisture from the atmosphere, and this physical characteristic may weaken the bond made with it. Hide glue is superior to bone glue. Prepared hide glue in liquid form ready for use is available in cans. The adhesive sets fairly quickly and does not absorb moisture from the air. Good bonds made with this adhesive are generally stronger than the wood itself. Surfaces coated with hot animal glue should be assembled or joined together quickly, before the glue begins to jell or set.

Prepared fish glue in cans is also marketed ready for use. This type of adhesive is slower setting, a property which may occasionally be advantageous. The finest quality of fish glue is made from skins only, and yields a stronger bond than hide glue. Fish glue, like animal glue, is not waterproof.

Casein glue is prepared from milk. It is available in a white powder form and as a prepared liquid. The powder is prepared for use by adding, as directed, approximately one measure of powder to one measure of cold water immediately before use. Casein is chemical-setting and a casein glue bond is very strong and fairly waterproof. A disadvantage of this alkaline glue is the possibility of its causing a brownish stain on hardwoods.

Synthetic resin adhesives are generally waterproof and make extremely strong bonds. The accelerator-set varieties are used with hardener-catalysts. All of these adhesives come ready for use and are generally nonstaining.

Polyvinyl resin glue is quick setting and easily applied, with about the same bonding strength as animal glue. It is not recommended for use where it may come into contact with metal or be exposed to moisture or high temperatures.

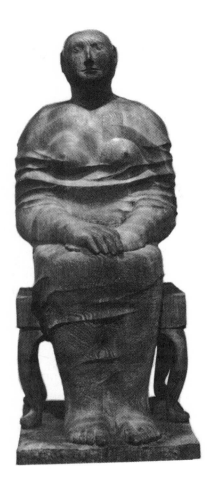

SEATED WOMAN, by Leonard Baskin.
1961. Oak. 54 inches high.
A truly superb example of the carving of a
laminated wood mass.

Pennsylvania Academy

Resorcinol resin glue is a completely waterproof adhesive available generally as a dark liquid with a powder catalyst. The required amount should be mixed by adding proportions of three measures or volumes of powder catalyst to four measures or volumes of liquid resin and stirring thoroughly. Since heat will accelerate the set, it is advisable, during warm weather or if the room in which the resin is being prepared is very warm, to cool the mixing container before use. The adhesive is applied to both surfaces and the units are then clamped securely together.

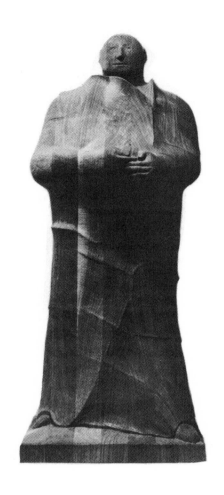

MAN WITH POMEGRANATE,
by Leonard Baskin. 1968. Walnut.
29½ inches high x 11¾ inches x
11¾ inches.
The varied graining of the laminated
sections of this sensitive and powerful
work adds markedly to the design and
visual effect of the wood carving.
Private Collection
Photograph courtesy
Grace Borgenicht Gallery

Urea resin glue yields a very strong, water-resistant bond. Generally, two measures of urea resin powder are added to ¾ measure of cool water. The powder is stirred into half the volume of water until a smooth mix results, at which time the rest of the water is added and the mixture stirred again. By reducing the amount of water, a thicker, quicker setting adhesive will result.

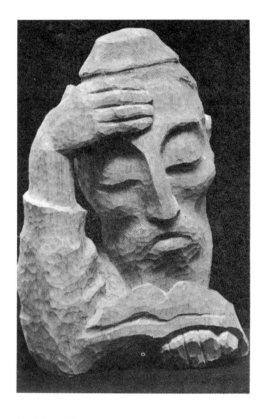

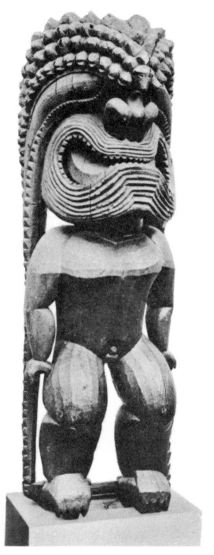

TALMUDIST, by Nat Werner.
A direct carving in cedar wood.
34 inches high.
In lobby of the Mount Sinai Hospital
Detroit, Michigan

HAWAIIAN WAR GOD. Early 19th century.
Carved wood. 81 inches high.
A rough and muscular, yet quite decorative
anthropomorphic representation of
Kukailimoku, God of war.
The British Museum

48

MAN DRAWING A SWORD, by Ernst Barlach (1870-1938). 1911. 29½ inches high.
A very powerful direct wood carving. It preserves the natural forms of the block and
achieves textural surface values by retaining the cutting marks.

The Museum of Cranbrook Academy of Art

Treatment

Many effects are possible with wood, from smoothly finished and highly
polished surfaces to rough and rugged effects where the chisel cuts are left
as part of the general design or treatment. The nature of the variety of wood
dictates the technique that is best employed and, therefore, directly influ-
ences form. Dense and tough varieties lend themselves to a broad treatment
and many wood carvers design in terms of masses rather than in linear
patterns for these hardwoods. These varieties will also take delicate details,
however.

The student should experiment with different cutting instruments and very
carefully observe the effects of light on the contour of the cuts.

FIGURE, by Henry Moore. Ebony. 9⅝ inches high.

Collection Michael Ventris

Finishing

Polychromy. Wood has been dyed, oiled, painted, polished, stained in imitation of other materials and other woods, waxed, gilded with metallic leaf, and completely masked with colored opaque lacquers.

The Egyptians frequently colored their wood carvings, and the architectural wood sculpture of the Greeks was very often externally colored. The Chinese and Japanese and other peoples produced a large amount of polychromed wood sculpture. The application of paint to wood carvings, however, tends to nullify and, frequently, to mask completely the natural texture and coloring of the individual wood. Gilding with metallic gold or silver leaf and the application of opaque, colored lacquers have a similarly camouflaging effect.

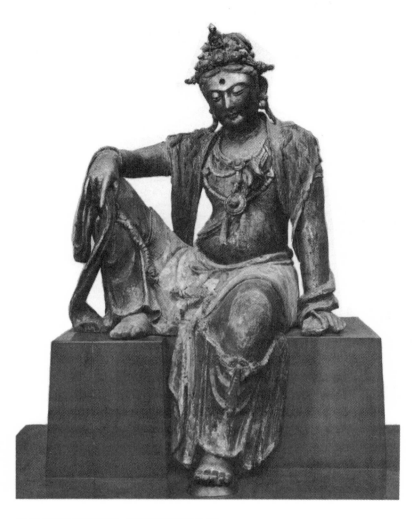

THE BODHISATTVA AVALOKITESVARA
KUAN-YIN SEATED IN THE ROYAL EASE POSITION.
Sung Dynasty, 12th Century. Wood. 55½ inches high.
In the 12th and 13th centuries, Chinese wood sculpture reached a high degree of perfection.

This large and impressive masterpiece is richly detailed and possesses a highly decorative and visually appealing quality. While the figure is in repose, it is alive sculpturally.

The Chinese sculptor, when working with wood as a medium, was frequently very naturalistic.

Museum of Fine Arts, Boston
Harvey Edward Wetzel Fund

51

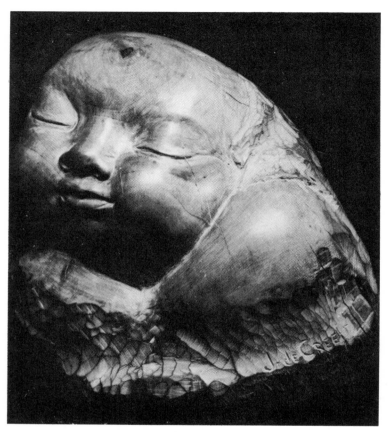

HEAD OF AN INFANT, by José de Creeft.
A direct carving in pearwood. Life size.
 Note the studied contrast of smoothly finished and polished upper areas and the rough
lower portions.

<div align="right">Collection Mrs. Elliot Blanc</div>

The contemporary tendency in sculpture is to respect the individual material and to exploit its individual qualities. All superficially applied opaque coloring is regarded as aesthetically objectionable, and wood carvings are usually left in a natural condition, lightly stained to achieve color and yet retain wood texture, or polished and lightly oiled or waxed to bring out the full depth and beauty of the natural color, grain, and texture of the wood variety. The inherent beauty of a wood can best be accentuated by careful polishing and by the conservative use of clear oils and waxes.

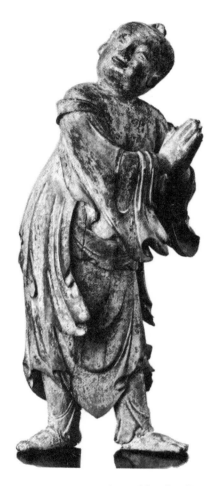

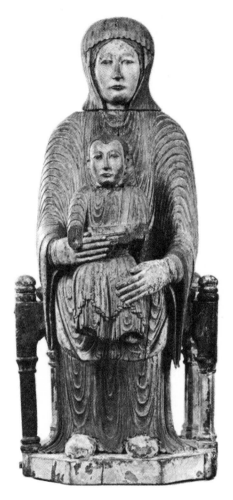

CHIN T'UNG TZU, "the golden boy".
Chinese, Late Sung Dynasty (?). 960-
1279 A.D.
Wood, covered with gesso and painted
with bright colors, which have since
faded. 27½ inches high.
The turned torso and the curving drapery
lead the eye around the carving and
create a feeling of happy movement
and life.

The Metropolitan Museum of Art

VIRGIN AND CHILD. French (School of
Auvergne). Second half of XII Century.
Polychromed oak. 31 inches high.
Only delicate vestiges of beautiful
coloring remain on this static, but
fine carving.

The Metropolitan Museum of Art

53

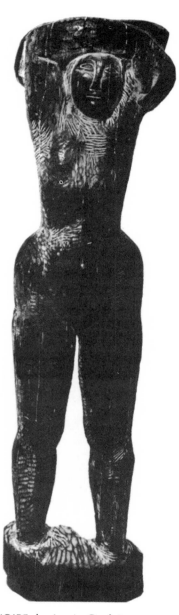

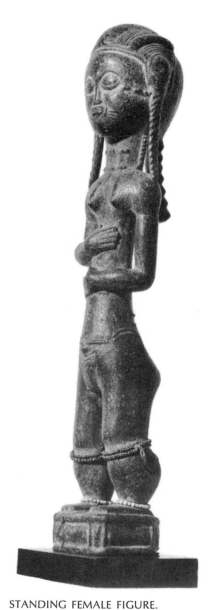

NOIRE, by Lorrie Goulet.
Charred oak. 56 inches high.

STANDING FEMALE FIGURE.
Ivory Coast: Baule. Wood, with glass beads,
white paint. 18½ inches high.
The Baule have a love for softwoods, which
they work tenderly.

The Museum of Primitive Art,
New York

54

Oiling. The application of an oil or wax and the subsequent polishing of a wood carving are the final finishing operations and they normally follow any repairing and sandpapering of the sculpture.

Woods are finished with oils and waxes for several reasons:

1. To fill the pore spaces and thereby seal the exposed surfaces of the wood against the effects of moisture penetration, temperature changes, and to minimize the staining and discoloring effects of atmospheric dust and grease.

2. To reveal the full natural beauty of color, and the depth and luster of the graining.

3. To change or intensify the tone or color of the wood, for while woods tend normally to darken and to mellow with the passage of time, the application of most oils and waxes to a finished wood carving will also tend to darken the wood more rapidly.

A very simple and commonly followed practice consists of applying thin coatings of boiled linseed oil with a soft clean cloth or cheesecloth to the finished wood carving. However, linseed oil generally darkens wood deeply and may leave a gummy residue if applied too heavily.

A so-called *French finish* can be made by mixing two parts of white shellac with one part of alcohol, by volume. About a dozen drops of olive oil are added to the mixture for each ounce of alcohol used. The solution should be throughly mixed and applied with a soft, clean cloth. Set the treated sculpture aside for a day to thoroughly dry and then rub down the entire wood carving surface with very fine steel wool. This procedure should be repeated several times, using fresh steel wool each time.

The final step consists of an application of wax and a polishing of the work with soft cloths or pads of soft felt.

Waxing and Polishing. It is a recommended procedure to apply wax to a wood carving in place of oil finishing or as a supplement to it. The practice will improve the appearance of most varieties of wood by revealing fully the natural color and graining. It should also be considered a very important measure in the preservation of a finished wood carving.

The piece of sculpture is generally coated with one or more applications of clear wax. The most frequently used wax for this purpose is beeswax, but this material, unfortunately, tends to hold atmospheric dust particles and to show finger marks when handled. Carnauba wax, which is secured from Brazilian palm trees, is an excellent finishing wax, but it is much harder physically than beeswax. A good clear or natural floor wax is usually satis-

SAINT PETER. Spanish. 13th to 15th Century.
Wood, polychromed. 19¼ inches high.
A somewhat static Apostle is seated on a bench holding
a book in his left hand; his hair is tonsured and he has
a short curling beard. He wears a dark blue mantle over
a robe showing traces of red color and gilded decoration.
The right foot is broken. The work is worm-eaten and
the paint chipped. The right hand has been restored
and the pigmentation and gilding are of a later date.
It is possible that the hair on the head has been recarved.
The forms of the sculpture are large, simple, and
well carved and designed.

Victoria and Albert Museum, London

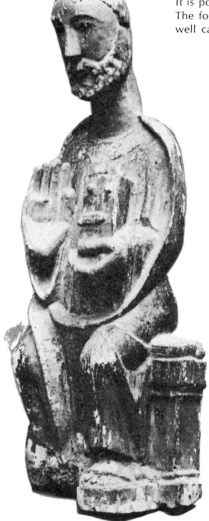

ONE AND OTHERS, by Louise Bourgeois. 1955. Hard pine, painted.
18¼ inches high, 20⅜ inches wide.
A visually appealing construction. The simplified, elongated and abstractly human forms are arranged in clusters which rise from the ground without bases. While each mass is unique, it is not isolated, but part of a warm, physically intimate group.

The Whitney Museum of American Art

factory for use in finishing wood carvings and should not stain the wood. It is advisable to test the preparation before using it on another piece of the same wood variety.

To prepare a finishing wax, first cut the chunks or pieces of wax into very thin slivers or shavings. These should be placed in a shallow dish, pan, or double boiler and covered with turpentine. Warm this very carefully over a low flame until the wax has thoroughly melted and then stir slowly to mix the melted wax and the turpentine. The mixture should now be removed from the flame and permitted to cool. When the mass has cooled, it should

have the consistency of a soft butter and can be applied to the wood carving with a soft, clean cloth or with a brush. Wipe off the surplus wax and set the work aside for a day or two before giving it a thorough manual rubbing with soft clean cloths or soft felt pads. This procedure should yield a fine polishing. Additional wax applications may be made, as desired.

A few sculptors advocate the application of a thin coating of diluted shellac to the carving before wax is applied and the work polished, feeling that the shellac solution will penetrate deeper and result in better sealing of the wood pores. Soft varieties of wood and those with fairly coarse graining

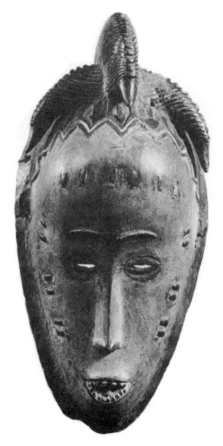

MASK. Ivory Coast: Guro. Wood, painted. 11½ inches high.
A fine example of the delicately beautiful and elegant Guro masks which were used for magical practices and religious ceremonies.

Museum of Primitive Art, New York

should be treated with a primer coating of thinned shellac before applying the wax-turpentine finish.

Staining. The wood surface to be stained should be free of glue or grease, which may prevent the penetration of the stain and result in a mottled or spotty effect. Before staining any wood it is advisable to first test the stain on a small piece of identical wood to determine the intensity of the stain and the resulting color. The staining should always be done prior to the final polishing of the piece.

The most adequate penetration of wood and coloring substance is achieved by the use of a vacuum process employing a water soluble stain. Some woods in the order of their suitability for this process are as follows: (1) apple, (2) hazel, (3) maple, (4) beech, and (5) birch.

A solution of gall-nut, to which has been added a minute quantity of a solution of ammonium vanadate is frequently used for this purpose.

Vehicles for Staining. Water vehicles penetrate excellently, but tend to raise the grain of the wood. A solution of approximately ¼ of an ounce of color is used to each pint of water.

Spirit vehicles penetrate fairly well, but raise the grain of the wood slightly. About 1 pint of denatured alcohol is used for each ¼ of an ounce of color.

Oil vehicles have only a superficial surface penetration, but do not affect the wood graining. Approximately ¼ of an ounce of oil-soluble color is used to each pint of benzine. Oil vehicles tend to be slow drying.

Varnish vehicles have little, if any, effect upon the graining of the wood. About ¼ of an ounce of oil-soluble color is generally used to each pint of varnish. The mixture should be thoroughly stirred until all of the coloring matter has been evenly dissolved, and the solution should be permitted to stand overnight before it is used.

Shellac vehicles have little, if any, effect upon the graining of a wood. About ¼ of an ounce of color is used to each pint of shellac solution.

Stains. The application of a priming coating of raw linseed oil and turpentine in equal parts will furnish a uniform foundation for subsequent oil stains.

Natural Stain

Refined turpentine	1 part
Raw linseed oil	1 part
Drier	½ part

The formula given above is used as a vehicle to which may be added colors ground in oil.

Mahogany Stain

Rose lake	1 part
Vandyke brown	2 parts

These proportions may be varied to secure a greater range of values from light mahogany to brown. The browns have a slight tendency to gray in time.

Walnut Stain

Walnut stain is made up of French ocher with red oxide of iron and lampblack in small quantities. Approximately 1 per cent of ocher is used.

Cherrywood Stain

Raw sienna	1 part
Burnt sienna	2 parts

These proportions can be varied to suit the individual requirements.

Light Oak Stain

Raw sienna	1 part
Raw umber	4 parts

Dark Oak Stain

Burnt umber	3 parts
Raw sienna	8 parts

A small quantity of burnt sienna can be added to this formula to secure a richer, deeper tone.

Imitation of Graining

The staining material should be thinned by the addition of a solution consisting of the following ingredients:

Raw linseed oil	2 parts
Refined turpentine	3 parts
Drier	1 part

This mixture is applied over the dry wood. Graining is achieved by dragging brushes across the wet surface until the desired effect is secured.

After staining a wood carving and allowing sufficient time to elapse for

thorough drying, the carving may be given a final protective treatment of orange shellac, diluted sufficiently with alcohol so that it does not result in a shiny surface on drying.

This is followed by the application of several coats of fine wax.

In the event that a waxed wood carving becomes water spotted, several conservative approaches should be considered. Solvents such as carbon tetrachloride or ether can be used to remove the wax from the sculpture, after which the wood surface is rewaxed. However, the use of any solvent strong enough to dissolve and thereby remove the wax may also "burn" the wood. Ether is extremely volatile and hazardous.

A gentle abrasive, such as powdered pumice stone or powdered pumice stone with rottenstone, can be carefully rubbed over the stained area with a piece of felt. If this treatment is successful, the area rubbed should be enlarged to gently diffuse the visual differences in appearance and the entire surface rewaxed.

The gentlest approach consists of rewaxing the entire wood carving with freshly prepared wax to which has been added a small amount of turpentine soluble stain.

PRESERVATION OF WOOD

Wood is a delicate material when its durability is compared with that of stone or metal sculpture. While under favorable conditions such as a cool and dry environment wood carvings will survive indefinitely, under adverse conditions of high humidity and extreme atmospheric temperature changes wood can be quite fragile.

Practically, a finished wood carving should be regarded as transformed and denuded organic material, without its protective bark and vulnerable to the destructive effects of atmospheric humidity, moisture, temperature changes, fungi, and parasitic or saprophytic insects. These are the major factors influencing wood decay.

As a general rule, wood will decay only when sufficient moisture is present to meet the requirements of most wood-rotting organisms. Termites, however, have the ability to attack and to digest wood which may be considered very well seasoned and yet possessing minute quantities of moisture. The major wood destroyers—fungi—generally require an abundance of moisture to thrive.

All wood varieties have a tendency to swell when moisture is absorbed and to shrink when the moisture evaporates. Fluctuating temperatures and conditions of atmospheric humidity may split a finished work in many places. I have seen large wood carvings develop really enormous cracks when the works were removed from the studio and placed on gallery exhi-

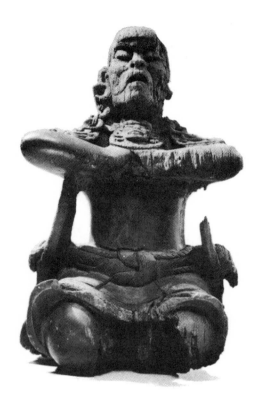

SEATED FIGURE, Mayan. Found in the Tabasco-Guatemala border area. 6th Century A.D. Wood, with traces of paint. 14 inches high.

A magnificent and extremely rare example of pre-Columbian wood sculpture. The figure is carved from a hard, dark reddish-brown tropical wood (family *Boraginaceae*, genus *Cordia*) which is native to southern Mexico.

The work was apparently colored and a thin wash of red hematite is still present on the well-preserved surfaces and in the deeper protected areas.

The carving is truly unique in view of the fact that it is made of wood, which is a perishable material, and that it comes from the wet tropical lowlands or rain forests of Middle America.

The preservation of an object made of wood in such a climate is quite remarkable. The sculpture may have been placed in a relatively protected environment such as a sealed cave or chamber, which would have provided insulation against high atmospheric humidity and moisture.

The Museum of Primitive Art, New York

63

bition. When the works were returned to the studio and to previous conditions of temperature and humidity, the deep, broad fissures slowly closed to a nearly normal condition. Occasionally, the use of a sealing and retouching material is required to fill the checks.

A mixture of wood dust that has been secured from the wood carving itself can be mixed with plastic wood or with wax and applied to the cracks. Wood shavings or actual wedges of identical wood, which have been shaped to fit the fissures, can be glued into deep cleavages and finished with an application of wood dust mixed with plastic wood. Wood dust from the carving may also be mixed with a polyester resin and used as a filler.

It is important, wherever possible, for the sculptor to select his wood for specific sites on the basis of environmental conditions such as ranges of temperature and general atmospheric humidity.

Wood may be treated artificially to increase its durability. There are two ways to do this:

1. The application to the surface of the wood mass of a superficial protective coating or layer such as lacquer, oil, paint, varnish, or wax, to partially seal the wood pores and establish a thin barrier to the entry of moisture and/or destructive organisms.

2. The impregnation of the wood mass to a varying degree of depth with chemicals which are either distasteful or poisonous to destructive organisms.

Some sculptors advocate saturating a wood carving by boiling it in linseed oil to preserve and strengthen it. This procedure is fairly coarse and may prove hazardous. The manual application of oil or wax to a finished carving will tend to minimize the dangers of cracking or warping.*

An industrial process has been developed whereby wood is impregnated with resin-forming chemicals, which react with the wood cellulose and alter its physical properties. The wood is thus made dimensionally stable under varying conditions of humidity and temperature. The hardness of the wood and its wearing and polishing qualities are thereby increased and the grain is not affected.

The British Museum and laboratories of museums in Copenhagen and

* The problem of protecting wood from decay and the ravages of insects is an ancient one. It is believed that the Egyptians who had developed the art of preserving organic bodies, also developed artificial means of preserving wood. Pliny writes of the use of essential oils, such as oil of cedar and olive oil, by the ancients for this purpose.

Zurich have experimented with methods of preserving wood by soaking works in a polyvinyl resin after first bathing the objects in alcohol and ether.

As stated before, heartwood is more durable and resistant to decay than sapwood, because of its density or lower porosity. The presence of natural preservatives such as resins and tannins in the heartwood are also very important preservative elements.

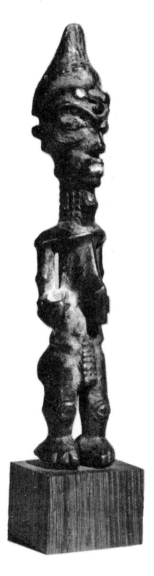

STANDING FIGURE. Congo (Kinshasa): Lulua.
Wood. 8⅜ inches high.
Most African sculpture is made of wood, because wood has been the most abundant and readily available material.

To the African wood carver the wood block remains a living mass throughout the carving process and cutting the wood is believed to cause it pain. For this reason there are many rites observed by the wood carvers, begging the spirit of the tree for forgiveness.

African wood carvings are almost invariably monoxylous, or fashioned from a single piece of wood, so that the tree or trunk shape is recognizable.

Very old African wood carvings are quite rare because the hot and generally humid native environment is conducive to wood decay.

The Museum of Primitive Art, New York

THE BASE

Properly mounting a finished work of art for presentation to viewers is a final and a very important phase of sculpture and it requires both a developed taste and a fine sense of proportion.

A well-designed base has a dual function: it is both decorative and functional, setting off and thereby enhancing the appearance of a piece of sculpture and also functioning as a support for a work that would not otherwise remain securely upright and balanced.

The base should be an integral part of the whole and not merely an extraneous slab. It should always enhance or supplement and never be more dominant than the sculpture it supports. Some sculptors will actually incorporate the base as part of the piece of sculpture and their primary concept of the forms to be cut from the wood includes the base mass.

The proportions of a base can be evolved by placing the carving on differently dimensioned rectangular or square or curved solids and then deciding which final mass would most satisfactorily enhance the piece of sculpture in terms of height, width, shape, and color. Another simple approach to this problem consists of roughly shaping a mass of modelling clay and then placing the work on this to judge proportions and shape.

The use of a mirror to view the work in reverse on its trial base is a recommended testing procedure. The mirror visually reverses the entire work and should enable the artist to readily detect any imbalances.

Attaching the wood carving to its base is a relatively simple procedure. The

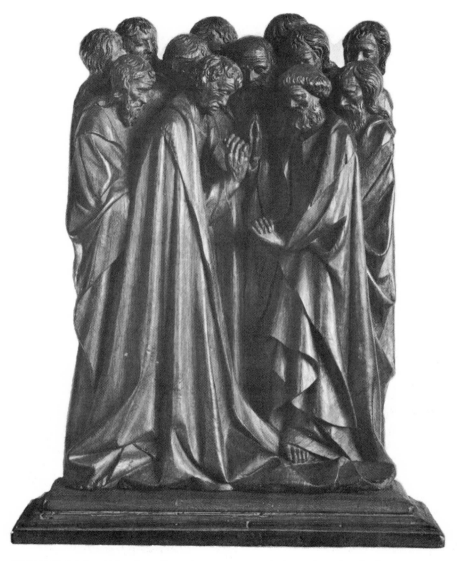

APOSTLES IN PRAYER. Flemish, early XV century. Oak. 19½ inches high.
This fine wood carving is closely related in its style to the stone tabernacle in the Church
of Notre Dame at Hal.

The Metropolitan Museum of Art
Gift of J. Pierpont Morgan

67

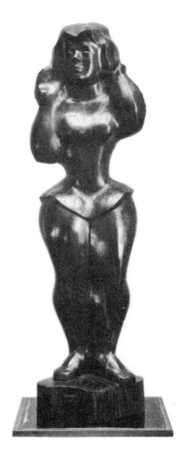

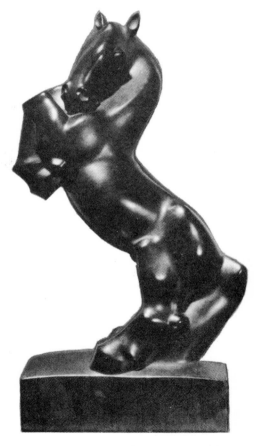

LILLIAN LEITZEL, by Chaim Gross.
Macassar Ebony. 52 inches high.
The Metropolitan Museum of Art
Rogers Fund

REARING STALLION, by Heinz Warneke.
Ebony. 16 inches high.

piece of sculpture should first be placed upon the base in its desired position. With a soft pencil or chalk trace the outlines of the carving on the base surface. The carving is now removed and one or two spots marked on the base surface at a distance sufficiently removed from the outline to minimize the possibility of splitting the carving when the fixing screws are inserted through the base. Holes are now drilled at right angles to the base top through the bottom of the base. The diameter of the holes drilled should be slightly less than the diameter of the screws to be inserted.

After the holes are drilled through the base, it should be turned over and the drill holes countersunk on the under surface to accept the screw heads.

The wood carving is now placed in position on the base, within the outline, and the points at which the screws will enter the sculpture are now marked through the base holes. Shallow holes are now drilled into the wood carving, but deeply enough to permit the screws to enter and hold securely.

Use brass screws, particularly if the creation is to be exposed in a humid environment, to minimize the possibilities of staining the base or the carving with rust marks. The use of nonferrous screws will also avoid the hazard of supporting screws becoming weaker as they rust, until they are finally unable to safely hold and support the sculpture.

The bottom or undersurface of a wood base is generally left rough. It should never be polished or waxed because this will result in an insecure and slippery surface. Some sculptors favor the practice of cementing a layer of felt or a thin sheet of foam or rubber to the undersurface of the base to both cushion the total weight and to provide a firm, nonabrasive clinging surface.

VARIETIES OF WOOD

The following list is by no means complete, since there are more than 50,000 species of wood known to scientists. The superb Samuel James Record Memorial Collection at Yale University, which is the largest collection of wood specimens in the world, contains more than 52,000 specimens.

The woods which are listed in this book include the better known and most frequently used varieties. Of the many other woods in existence, many have been or are being used in native carvings, but not all of these woods are generally available.

The references given in the bibliography may be consulted for additional varieties.

Abachi, see *Ayous.*
Abarco, see *Albarco.*
Abiache, see *Opepe.*
Aboudikrou, see *Sapele.*
Acacia (Acacia spp.) is a relatively rare wood, species of which are grown in America, Europe, and the Near East. It is quite infrequently used for wood carving. The "false acacia" or "locust tree" (*Robinia pseudo-acacia,* Linn.) is grown in the United States.
"Acacia" Burl, see *Laurel.*
Acana, see *Beefwood.*

Acapa, see *Sucupira.*

Acapu, see *Sucupira.*

Achi, see *Agba.*

Acle, see *Akle.*

Afara, see *Korina.*

Afara, Black, see *Emeri.*

African Black Walnut, see *Mansonia.*

African Blackwood, see *Ebony.*

African Bubinga, see *Rosewood.*

African Cedar, see *Bosse.*

African Ebony, see *Ebony.*

African Gaboon Ebony, see *Ebony.*

African Mahogany, see *Mahogany.*

African Padouk, see *Padouk.*

African Rosewood, see *Rosewood.*

African Teak, see *Iroko.*

African "Walnut", see *Tigerwood.*

African Whitewood, see *Ayous.*

Afrormosia (Afrormosia elata) is also referred to as *Bonsamdua, Devil's Tree, Kokrodua,* and *Redbark.* It is an attractive light to medium brown wood from West Africa. It resembles Burmese teakwood, particularly after it has been cut and as time passes, when the color gradually changes from a yellowish to a warmer brown on exposure to the air and light. Afrormosia weighs about 45 pounds per cubic foot.

Agba (Gossweilerodendron balsamiferum, Harms.) is also known as *Achi, Moboron, Nigerian Cedar, Pink Mahogany,* and *Tolabranca.* It is a creamy white to pale brown tropical hardwood from Nigeria. The heartwood is a bit darker than the sapwood, but the basic color is the same. Agba is secured from huge trees which grow to more than 100 feet high, frequently achieving diameters of up to 6 feet. Agba is relatively light in weight, the seasoned wood weighing about 32 pounds per cubic foot. The wood is rather gummy or resinous and it has a tendency to check.

Akle (Albizzia acle) is also referred to as *Laurak.* It is a dark brown hardwood from the Philippine Islands which is easily carved, although it is fairly hard and rather heavy.

Ako, see *Chen Chen.*

Akume, see *Rosewood.*

Alaska Cedar, see *Cedar.*

Albarco (Cariniana spp.) is also called *Abarco, Cedro Macho,* and *Jequitaba.* It is a hard and heavy tropical wood from Brazil and Colombia. The heartwood varies in color from a yellow brown to a reddish brown.

Alder (Alnus rubra, Bong.) is a pale brown to whitish wood from the west coast of the United States. It is readily available and has good working qualities.

Allacede (Wallaceodendron celebicum) is also called *Banuyo.* This light brown to brown, rather coarse-grained Philippine hardwood is relatively inexpensive, but difficult to secure in the United States.

Almique (Manilkara jaimiqui) is also called *Gonsella.* It is a reddish-brown wood which is imported from Cuba and the Guianas. The wood is hard, heavy and compact and takes a fine polish.

Almon, see *Mahogany.*

Almond (Prunus communis, Fritch) is a beautiful fine-grained reddish-brown fruitwood from the Mediterranean area. It is generally expensive and not readily available.

Alpine Birch, see *Birch.*

Amarante, see *Amaranth.*

Amaranth (Peltogyne paniculata, Benth.) is also known as *Amarante, Bois Violet, Morado, Palo Morado, Purpleheart* and *Violetwood.* Amaranth is a rich, violet-colored tropical hardwood which is imported from Brazil, Central and South America, Mexico, and the Guianas. It is a close and even-textured wood, which is hard and heavy and carves excellently. The wood is generally available in plank form varying from approximately 1 to 6 inches in thickness, 10 or more inches in width, and from 6 to 21 feet in length. The wood weighs about 62 pounds per cubic foot. It is relatively expensive.

Amarello, see *Satinwood,* Brazilian.

Amargoso (Vatairea spp.) is a tropical orangy-brown hardwood, which is native to eastern South America. The wood is rather brittle, coarse and heavy and it is difficult to secure.

American Bald Cypress, see *Cypress.*

American Beech, see *Beech.*

American Elm, see *Elm.*

American Mahogany, see Mahogany

American Oak, see Oak.

American Sycamore, see Sycamore.

American Walnut, see Walnut.

American Whitewood, see Basswood.

American Yew, see Yew.

Amoteak, see Sucupira.

Andaman Padouk, see Padouk.

Andiroba (Carapa guianensis, Aubl.) is also known as Carapa, Cedro Macho, Crabwood, Demerara, and "Mahogany" Demerara. Andiroba is a reddish-brown, generally straight-grained, but fairly coarse-textured hardwood from northern South America.

Angelim Amargoso, see Amargoso.

Angola Padouk, see Padouk.

Angouma, see Okoume.

Apaya, see Avodire.

Appayia, see Avodire.

Apple (Pyrus malus, L.) is a close and even-grained, rather soft light wood, which is suitable for small pieces and a delicacy of detail and which takes a good finish. The sapwood is a light red color and the heartwood is a reddish brown. Applewood is grown in Asia, Europe, and the United States. The imported varieties are invariably superior to the commercially available domestic types for wood carving. European apple weighs about 48 pounds per cubic foot. Applewood is generally available in small logs of a maximum diameter of about 10 inches and a length of about 36 inches. (A log is a tree trunk with the bark removed and the branches lopped off.) Applewood must be seasoned very carefully because the wood has a tendency to warp and to split in drying.

Aprono, see Mansonia.

Araca (Terminalia aff. januarensis, D.C.) is a fairly rare yellow-brown to olive-brown heavy Brazilian hardwood with straight darker-brown stripes.

Argento, see Eucalyptus.

Ash, American, heartwood varies from a light to a dark grayish-brown color. There are several varieties of ash, which are generally hard, heavy, and brittle open-grained woods of intermediate durability.

1. *Black Ash (Fraxinus nigra,* Marsh) is also known as *Brown Ash, Hoop Ash,* and *Swamp Ash.* The heartwood is a warm brown color. The sapwood is light brown. Black ash is fairly durable, heavy, but rather soft. It is moderately priced and generally available.
2. *White Ash (Fraxinus americana,* Linn.) is a light cream to delicate brown wood. It is also quite durable, hard and heavy, and readily available.

The open grain of ash makes it somewhat difficult to carve and to finish. The wood weighs about 45 pounds per cubic foot.

Ash, European (Fraxinus excelsior, Linn.) is also referred to as *Italian Olive Ash.* It is a light grayish color, even-grained, easily worked hardwood, which is fairly scarce and quite expensive when it is available. The wood is imported from England, France, Hungary, and Turkey.

Ash, Japanese (Fraxinus sieboldiana, Blume) is also called *Damo and Tamo.* This variety is lighter in weight than the American and European ash. It is a light straw or blond color with a beautiful darker-brown graining. Japanese ash is quite scarce and fairly expensive.

Ash, Mountain, see *Eucalyptus.*

Aspen (Populus alba, Linnaeus). Aspen is native to Europe and Western Asia, but has been transplanted to the United States. It is also referred to as *English Poplar, Silver Poplar,* and *White Poplar.* The sapwood is nearly white. The heartwood varies in color from a very delicate yellow to different tints of tan and brown. Aspen is physically soft, light and weak, but close-grained and easily worked.

Aspen, Northern, see *Poplar.*

Australian Blackwood (Acacia melanoxylon) is also called *Tasmanian Blackwood.* The wood is close-grained and has a rich reddish-brown color, frequently attractively figured. It is easily carved and takes a good polish.

Australian "Laurel", see *Oriental Wood.*

Australian Silky "Oak", see *Lacewood.*

Australian "Walnut", see *Oriental Wood.*

Austrian Oak, see *Oak.*

Avodire (Turraeanthus africana, Pell.) is also known as *Apaya, Appayia, and Olon.* Avodire is a very light colored African hardwood with a beautiful figuring. The color of this wood varies from an almost white to a creamy golden tint. It grows in the Cameroons and

in Liberia. Avodire is fairly firm and strong and has a clean grain. The wood weighs about 25 pounds per cubic foot. It is largely used for decorative purposes and is generally moderately priced and available in plank form.

Ayous (Triplochiton scleroxylon, K. Schum.) is also called *Abachi, African Whitewood, Ewowo, Obeche, Okpo, Samba,* and *Wawa.* It is a fairly light, but firm and even-textured tropical hardwood which is similar to avodire, but it is softer and possesses more marked graining. This creamy white to delicate yellow wood is imported from the French Cameroons, the Gold Coast, the Ivory Coast, and Nigeria. It is usually available in large logs and is relatively inexpensive. Ayous weighs about 25 pounds per cubic foot. It carves very well and takes a fine polish.

Bagtikan, see *Mahogany.*

Bahia Rosewood, see *Rosewood.*

Baku, see *Makore.*

Balata, see *Beefwood.*

Balsa (Ochroma lagopus) is characterized chiefly by its extremely light weight and its softness. Balsa wood weighs between 5 and 10 pounds per cubic foot. The wood was used from pre-Columbian times by the natives of Central and South America for making boats and canoes. The name *balsa* is the Spanish word for raft. Balsa wood is very easily cut, most satisfactorily with a thin, sharp blade, but it is rarely used sculpturally because its surface is so easily marred and the mass destroyed. The wood, which is extremely porous, varies slightly in color from a pale white to a yellowish tint. It is imported from Central America, Ecuador, Southern Mexico, and the West Indies. Balsa is in plentiful supply and is commercially available in planks and blocks.

Balsamo, see *Rosewood.*

Balustre or *Balaustre* is a brilliant orange-colored wood which is imported from South America. Logs vary in size up to about 8 inches in diameter and 8 or more feet in length.

Banak (Virola koschnyi) is a tropical hardwood which grows in British Honduras, Guatemala, and Panama. The wood is a pink-tinted brown which darkens after cutting and exposure to the air and light. It has a tendency to warp and to split in seasoning and much care has to be observed to prevent or to minimize these

possibilities. Banak is a moderately hard wood with a fairly straight grain. It weighs about 28 pounds per cubic foot. Sharp tools are required to carve banak. Care should be observed in selecting clean logs of this variety which all too frequently are defective and either stained or damaged by pin worms.

Banuyo, see *Allacede.*

Basswood (Tilia americana, L.) is also known as *American Whitewood* and *Linden.* It is a fairly common North American and Canadian softwood with a fine straight and close grain, but with little grain character. The wood is light in weight, quite soft physically, compact, and easily carved. The color of the heartwood varies from a creamy white to a medium reddish brown. It has little durability when used under conditions favoring decay. The wood weighs about 26 pounds per cubic foot and is generally in plentiful supply.

Batoa, see *Boxwood,* West Indian.

Bayott, see *Bella Rosa.*

Bay Poplar, see *Gum Tupelo.*

Baytree, see *Laurel.*

Beanwood, see *Blackbean.*

Beech, American beechwood (Fagus grandifolia, Ehrh.) which is also known as *Sweet Beech,* and the *European beechwood (Fagus sylvatica,* Linn.) are similar in appearance. Beech is a tough, strong hardwood with variable qualities of durability. The sapwood is fairly white and the heartwood is of a reddish color. Beechwood is quite close grained and takes a very fine polish, but has a tendency to check during seasoning. It is readily available and quite inexpensive. See also *Ironwood.*

Beefwood (Manilkara bidentata) is also referred to as *Balata, Bulletwood, Red Lancewood, South American "Mahogany"* and *Wild Dilly.* It is a reddish-brown hardwood with a violet tint which is imported from Brazil, British Guiana, Dutch Guiana, Surinam, and Venezuela. The wood may prove somewhat brittle in working, but is very durable and takes a smooth finish. Beefwood is a hard, durable, heavy, and costly wood which is generally available in large logs. The variety secured from British Guiana very frequently has an abundance of knots. The wood weighs between 55 and 61 pounds per cubic foot.

Bella Rosa (*Anisoptera thurifera*, Blume) which is also known as *Bayott*, *Duali* and *Palosapis* is a fine and beautiful pinkish to yellow buff-colored Philippine hardwood. Bella rosa is heavy, has a rather coarse texture, a generally straight grain and a pinkish striping. It is moderately priced when available.

Benge (Guibourtia aronoldiana) is a light brown hardwood from the African Gold Coast, with dark stripes. The variety is a fairly open-pored wood which is generally inexpensive when available.

Benin "Walnut", see *Tigerwood*.

Bethabara is an oily, fine-textured and very hard dark-brown wood which comes from the Guianas.

Big Leaf Maple, see *Maple*.

Bilinga (*Sarcocephalus trillesi*, Pierre) is a fairly plentiful and moderately priced African West Coast hardwood. The wood varies in color from a yellow to a tan tint.

Birch grows in Asia, Europe and North America and is available in many varieties,[1] but the wood, while hard, strong, fine-grained and beautiful, is generally not very durable on exposure to the elements. Commercially, birch is divided on the basis of the quality of heartwood present, into red birch and white birch. *Alaska White Birch* (*Betula neoalaskana*) is a rarely used variety. *European Birch* (*Betula alba*, Linn.) is also called *Alpine Birch* and *Finnish Birch*. It is a fine-grained hard variety with burl-like markings. The wood is quite scarce and expensive.
Sweet Birch (*Betula linta*, Linn.) is also referred to as *Black Birch* and *Cherry Birch*. It is a relatively hard and heavy and abundant species which grows in the Adirondack and eastern Appalachian mountains of the United States. The sapwood is a light yellow to brownish color.

Yellow Birch (*Betula alleghaniensis*) is also known as *Gray Birch, Silver Birch,* and *Swamp Birch*. It grows abundantly in Canada and the northeastern portion of the United States. The sapwood varies from a light creamy brown to a near white color. It is a strong wood, much harder than gumwood. The pores of this variety are finer than those of mahogany, but not so fine as the pores in gumwood.

[1] There are some twenty-four known species of birch.

Bird's Eye Maple, see *Maple.*

Black Afara, see *Emeri.*

Blackbean (Castanospermum australe) is also known as *Beanwood* and as
Moreton Bay Chestnut. It is a medium to dark brown, almost black
Australian hardwood with streaks of lighter color. It resembles
teakwood. The wood is relatively heavy and fairly coarse-textured.
It carves well and takes a nice polish, and is fairly resistant to
decay. It is, however, difficult to secure and rather costly.

Black Birch, see *Birch.*

Black Cherry, see *Cherry.*

Black Ebony, see *Ebony, Gaboon.*

Black Walnut, see *Walnut.*

Blackwood, see *Rosewood.*

Blanco, see *Primavera.*

Blue Beech, see *Ironwood.*

Blue Gum, see *Eucalyptus.*

Bois de Rose, see *Tulipwood.*

Bois de Rose d'Afrique, see *Rosewood.*

Bois Violet, see *Amaranth.*

Bombay Rosewood, see *Rosewood.*

Bonsamdua, see *Afrormosia.*

Bosse (Guarea cedrata, Pellegr., *Guarea thompsoni)* is a strong and tough
hardwood which is also known as *African Cedar, Cedar Mahogany,
Cedron, Kwi, Obobo,* and *Pequa,* or *Piqua.* Bosse is a delicately
figured, light pink to pale mahogany-colored tropical wood from
the Gold Coast, the Ivory Coast, and Nigeria. The heartwood
darkens on exposure to the atmosphere. Bosse has a straight to
wavy graining. It gives off a rather strong cedar-like odor when it
is carved. The wood is generally moderately priced when it is
available, occasionally in logs up to 5 feet in diameter.

Box Elder (Acer negundo, L.) is another name for Ash-leaved Maple. Box
elder grows in Canada and in the United States. The heartwood is
a bronzy color. Box elder is close-grained, but is also light and
soft. It is a relatively inexpensive wood, but is not always available.

Boxwood (Buxus sempervirens, Linn.) or *Indian Boxwood* is a very
fine-textured light yellowish-color hardwood from Asia and
Europe. The wood is close and straight grained with no grain
limitations. It is an excellent wood for carving, but is usually

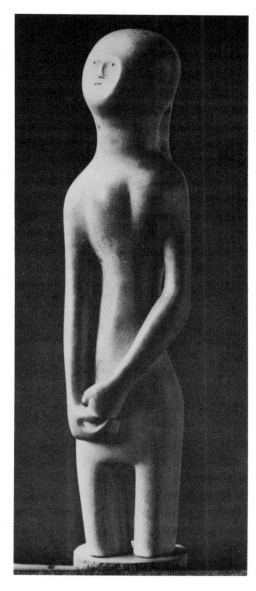

GIRL, by Henry Moore. Boxwood. 12 inches high.
Collection Miss Barbara Hollweg

79

available in only relatively small pieces or logs and is quite costly. *Turkish Boxwood* is superior to the West Indian variety for sculptural purposes. The wood sometimes gives off a sweet odor when it is cut. Boxwood was popular in ancient Greece.

Boxwood, West Indian (Gossypiospermum praecox) is also known as *Batoa, Maracaibo Boxwood,* and *Zapatero.* It is a light yellowish-white colored and fine-grained hardwood from Colombia, the West Indies, and Venezuela. The Venezuelan variety has a strong odor. Boxwood is a generally straight grained and firm but very heavy wood, which is easily carved. It is not readily available and is generally expensive when it is. Boxwood has proven irritating to the skin of some wood carvers.

Braziletto or *Brazilwood* is a South American variety of hardwood, which is generally available in small logs up to about 5 inches in diameter. It has been used for making violin bows.

Brazilian Cedar, see *Cedar, Spanish.*

Brazilian Padouk, see *Macacauba.*

Brazilian Pinkwood, see *Tulipwood.*

Brazilian Rosewood, see *Rosewood.*

Brazilian Satinwood, see *Satinwood.*

Brazilian Walnut, see *Imbuya.*

Breadnut, see *Capome.*

Brown Ebony, see *Ebony.*

Brown Elm, see *Elm.*

Brown "Mahogany", see *Edinam.*

Bubinga, see *Rosewood.*

Buckeye (Aesculus glabra, Willd.) is also called *Horse Chestnut* and *Ohio Buckeye.* It is a very pale, almost white wood from the eastern United States. The wood is relatively soft and close-grained, but not strong. It is moderately priced.

Bulletwood, see *Beefwood.*

Burma or *Burmese Padouk,* see *Padouk.*

Butternut (Juglans cinerea) is also called "white walnut", although it is softer than walnut and differs in color. The color of butternut heartwood is a grayish-brown that darkens on exposure. It is a minutely pored, fairly homogeneous, coarse-grained wood of medium hardness with occasional spots or streaks. Butternut is quite compact physically and carves easily. However, very sharp

tools should be used because of the softness of the wood. Butternut is capable of taking a very high polish, but does not wear well. The wood grows in the north central United States and southern Canada, but while it is generally moderately priced, it is infrequently available.

Buttonball, see *Sycamore.*

Buttonwood, see *Sycamore, American.*

Calabar, see *Ebony, Gaboon.*

California Laurel, see *Laurel.*

California Sycamore, see *Sycamore.*

Camphor Wood (Cinnamomum camphora) is an exotic scented tropical hardwood which grows in Borneo, China, Formosa and Japan, and is imported from Borneo and Formosa. The Borneo variety tends to shrink markedly and must be very carefully air-seasoned for a few years. It is generally available in plank form, approximately 4 inches in thickness.

Canaletta (Cordia gerascanthus, Linn.) is also called *Canalete, Canalette, Cyp, Cypre, Princewood, Solera,* and *Ziricote.* It is an attractive violet to dark reddish-brown Venezuelan hardwood which is not frequently used for wood carving because it is quite difficult to secure and expensive when it is available. The wood is very hard, but carves easily. It is beautifully figured.

Canary Wood, see *Satinwood.*

Canella, see *Imbuya.*

Capome (Brosimum alicastrum, Sw.) is also called *Breadnut, Capomo, Laredo, Lerado, Ogechi, Ojoche,* and *Ramon.* Capome is a light colored Central American hardwood which is rather infrequently employed for wood carving, although it is generally available and moderately priced. The heartwood of this species is a reddish color, and the sapwood yellowish.

Carapa, see *Andiroba.*

Carpathian Burl, see *Elm.*

Cashew Wood is very rarely used by the sculptor. It is generally believed that the sap of the tree is irritating to the skin.

Castor Arabia, see *Sen.*

Catalpa (Catalpa speciosa, Warder) is a brown-colored light and relatively softwood from the southern part of the United States. The wood is rather weak physically and brittle, although close grained. It is

a scarce wood, but moderate in cost when it is available.

Cativo (*Prioria copaifera*, Grid.) is also known as *Florisa, Spanish Walnut, Tabasara,* and *Taito.* Cativo trees flourish in the tropical parts of Central America, South America, and the West Indies. The heartwood of this straight grained, but rather stringy hardwood is brown and the sapwood is a dusky white color. The wood is generally available and low in cost.

Cedar, African, see *Bosse.*

Cedar, Aromatic Red, (*Juniperus virginiana*, Linn.) is also referred to as *Eastern Red Cedar, Juniper, Pencil Cedar, Red Cedar, Southern Red Cedar* and *Tennessee Red Cedar.* This species flourishes over most of the eastern parts of the United States. It is most prolific in the southeastern and south central States.

Cedar is a durable, pleasantly scented, soft and light wood, which, unfortunately is quite brittle. The colors vary from a yellow and light red to a deep brown. Knotty patterns are frequently present. Red cedar is fine-grained and very easy to carve. The white cedar varieties are generally soft, weak woods.

Alaska Cedar is a harder, yellow variety.

Cedar is generally available in small pieces and is moderately priced.

Cedar, Brazilian, see *Cedar, Spanish.*

Cedar, Central American, see *Cedar, Spanish.*

Cedar Mahogany, see *Bosse.*

Cedar, Red, see *Cedar, Aromatic Red.*

Cedar, Southern Red, see *Cedar, Aromatic Red.*

Cedar, Spanish (*Cedrela odorata*) is also known as *Brazilian Cedar, Cedrela, Cedro,* and *Honduras Cedar.* It is not a true cedar variety, but the wood is favored by some wood carvers for sculpture. It grows in all of the Central and South American countries except Chile. The wood is a light red color with graining which varies from quite straight to curly and even mottled. It is rather soft, is readily available and reasonably priced.

Cedar, Tennessee Red, see *Cedar, Aromatic Red.*

Cedrela, see *Cedar, Spanish.*

Cedro, see *Cedar Spanish*

Cedro Macho see *Andiroba.*

Cedron, see *Bosse.*

82

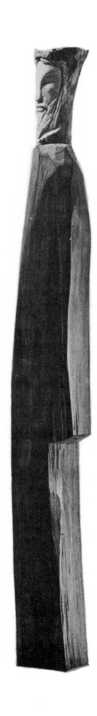

THE JUDGE, by José de Creeft. Cedar and bone.
About 2 feet high.

Collection Mrs. L. A. Cohn

Ceiba (Ceiba pentandra) is also known as *Kapok, Odoum,* and *Silk Cotton Tree.* It is very rarely used sculpturally. The wood grows in Mexico and West Africa. It is a reddish-gray wood with gray or yellowish streaks. Ceiba has a rather coarse texture and is quite brittle. It is generally available and is not costly.

Celtis (Celtis soyauxii, Engl.) is also referred to as *Ita, Itako,* and *Ohia.* It is a West African pale yellow to whitish heavy hardwood which is fairly scarce.

Ceylon Satinwood, see *Satinwood.*

Chen Chen (Antiaris africana) is also referred to as *Ako* and *Quen Quen.* The wood, grown from the African Gold Coast to the Cameroons, is relatively soft, light in weight, and carves well. Chen Chen varies in color from white to yellowish gray. It is generally inexpensive when it is available.

Cherry (Prunus serotina, Ehrh.) is also called *Black Cherry, Rum Cherry,* and *Wild Black Cherry.* Cherry is a close-and straight-grained hard fruitwood with minute pores. The wood is relatively light, weighing about 35 pounds per cubic foot. Its heartwood is light to darker reddish brown, somewhat similar in color to mahogany, and is excellent for wood carving since it is quite compact physically. Cherry wood grows in the United States from the state of Maine to the Dakotas. Areas of greatest abundance are from Pennsylvania to West Virginia.
Cherry wood can generally be secured in rather large logs a foot or more in diameter and is moderately priced.

Cherry, African, see *Makore.*

Cherry Birch, see *Birch.*

Cherry, Choke (Prunus virginiana, L.) is a hard and heavy light brown fruitwood which, while fairly close-grained, is not strong. Choke cherry grows from the Hudson Bay southward to Kentucky and Oklahoma. It is a fairly scarce wood.

Cherry, French (Prunus cerasus, Linn.) is a hard fruitwood which is native to England and France. It is physically similar to American cherry, but has a yellowish-brown heartwood. The wood is very rarely available in the United States.

Cherry Mahogany, see *Makore.*

Cherry, Wild (Prunus avium, Linn.) is a hard fruitwood which grows most abundantly in Asia Minor, Europe and Great Britain. The wood

84

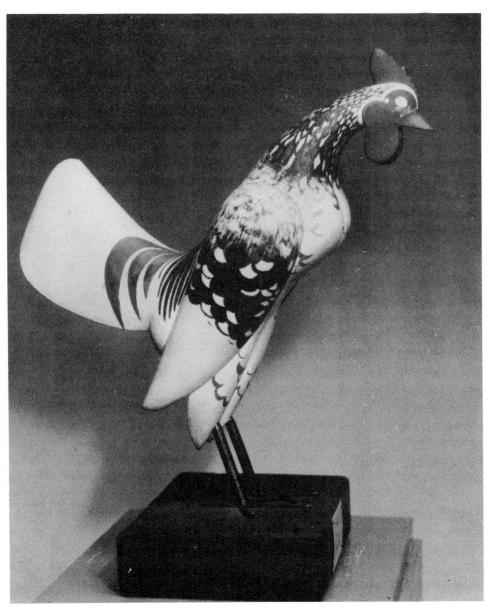

COCK, by Emma L. Davis. 1932. A painted carving in
cherry wood, mounted on copper legs. 13½ inches high.
Whitney Museum of American Art

is a pinkish color when it is first cut which darkens on exposure to the air. It is generally expensive when available.

Chestnut (*Castanea vulgaris*), the common chestnut, is a light, soft, and coarse-grained wood. It is fairly weak physically and is susceptible to a checking and warping in drying, so that it has to be very carefully seasoned. The wood, however, is fairly durable and is easily worked. Chestnut heartwood varies from a cream to a reddish-brown color, with a lighter sapwood. Chestnut is becoming very scarce due to the chestnut blight, a fungous disease. Dead, standing chestnut trees should be avoided as a source of the wood, because the trees may be riddled by insect holes and, therefore, quite unsuitable for sculptural purposes. Carving of the wood may also present difficulties because blocks are quite frequently not very homogeneous. Hard portions may adjoin soft areas and carving this wood should be accomplished quite slowly and cautiously.

Chittam (*Cotinus obovatus*), the biblical chittam wood, is also called *Smoke Tree*. Chittam is a wood which is very rarely available commercially. The heartwood has an orangy color and the sapwood is frequently a near white.

Cinnamon (*Cinnamomum zeylanicum*, Breyn.) is a rare tropical hardwood imported from Ceylon. The wood has a fine grain and varies in color from a straw or light tan to a dark brown.

Cocobolo (*Dalbergia granadillo*, Pittier: *Dalbergia hypoleuca*, Pittier: *Dalbergia retusa*, Hemsley) is a yellow-brown to reddish colored tropical hardwood imported largely from Central and South America. It is very hard and dense and quite difficult to carve. Some individuals are allergic to the wood and develop rashes, water blisters, and a swelling of those parts of the body touched by the dust or shavings. The physical reactions are quite similar to the effects of poison ivy. Large blocks of cocobolo are frequently hollow because of internal decay. Paradoxically, a finished carving in this wood resists decay well. Small pieces of cocobolo are usually compact. The wood is widely used for making knife handles. Cocobolo weighs between 60 and 75 pounds per cubic foot and is rather expensive when available.

Coffeewood, see *Ebony*.

Congowood, see *Tigerwood*.

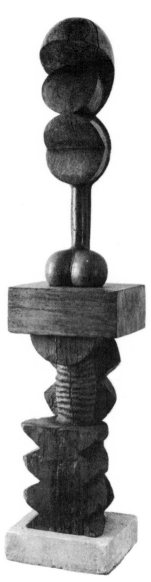

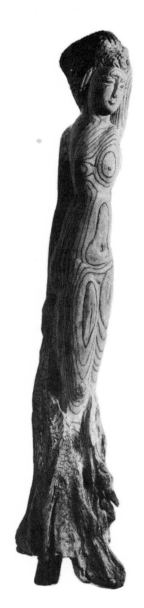

ADAM AND EVE, by Constantin Brancusi.
1921. Chestnut, one section; old oak, two
sections. 88½ inches high. Limestone base
5¼ inches high.
 The Solomon R. Guggenheim Museum

NEID, by Lorrie Goulet.
Chestnut wood. 46 inches high.

87

Corail, see *Padouk.*

Coromandel, see *Ebony, Macassar.*

Cotton Gum, see *Gum, Tupelo.*

Cottonwood, see *Poplar.*

Crabwood, see *Andiroba.*

Cuban Mahogany, see *Mahogany.*

Cucumber Tree, see *Magnolia.*

Cyp, see *Canaletta.*

Cypre, see *Canaletta.*

Cypress (Taxodium distichum, Rich.) is a close, straight-grained wood, which is fairly soft and quite light in weight. It is easily carved and has a delicate resinous odor, but is not very strong physically, although it is very durable even when used under conditions favoring decay.

Cypress heartwood varies from a light umber color to a darker salmon-brown.

The common *American Bald Cypress* is a species which thrives in several southeastern states of the United States. It grows along river banks, in wet bottomlands, and in the shallow waters of lake shores.

Cypress "knees" are stumplike growths resembling driftwood. They are, actually, root protuberances, permitting the trees to "breathe" in their watery habitat. The knees are fine-grained and quite hard, with suggestive gnarled beauty.

Damo, see *Ash, Japanese.*

Dao, see *Paldao.*

Degame, see *Lemonwood.*

Demerara, see *Andiroba.*

Determa, see *Imbuya.*

Devil's Tree, see *Afrormosia.*

Dikela, see *Wenge.*

Dogwood (Cornus florida, Linn.) is also referred to as *Flowering Dogwood.* Dogwood is a fairly fine, straight-grained, pinkish-white to yellowish-brown, hard and heavy variety. It grows from British Columbia to Central America and is generally available in small logs of 3 or 4 inches in diameter and about 4 feet in length. The The wood is usually costly. Dogwood weighs about 50 pounds per cubic foot.

88

Duali, see *Bella Rosa.*
Durango, see *Primavera.*
Eastern Oak, see *Oak.*
Eastern Red Cedar, see *Cedar.*
East Indian Laurel, see *Laurel.*
East Indian Rosewood, see *Rosewood.*
East Indian Satinwood, see *Satinwood.*
East Indian Walnut, see *Laurel,* also *Koko.*
Ebony (*Diospyros tomentosa, Diospyros ebenum,* and *Diospyros assimilis*)
is a dense, smooth-grained, heavy, tropical hardwood which is
quite expensive and difficult to secure in substantial sizes. It is
generally jet black, but there are also reddish and greenish
varieties. The finest variety of ebony is *African Gaboon Ebony*
(*Diospyros dendo*) which is almost pure black in color. It is also
referred to as *Black Ebony, Calabar, Gabun,* and *Lagos.* This wood
is very hard, rare, and costly. It is rather difficult to carve and is
usually available in small logs approximately 8 inches in thickness
and 40 inches in length. African ebony weighs about 78 pounds
per cubic foot. Wormholes are very frequently present in African
ebony, but they are so minute that they cannot be readily detected
in the rough log.
Macassar Ebony (*Diospyros melanoxylon*) is also called *Coro-
mandel* and *Marblewood.* It comes from the Dutch East Indies.
This dark brown to black variety, with yellow to yellow-brown
streaks, can occasionally be secured in logs a foot or more in
diameter and 7 or more feet in length. Macassar ebony, is,
however, considered by many wood carvers to be inferior to
the African variety. It is also dense and close-grained and weighs
about 70 pounds per cubic foot. Larger logs are quite frequently
defective. The wood is scarce and costly when it is available.
Brown Ebony, which is also known as *Coffeewood, Grenadilla,
Partridge Wood,* and *South American Grenadilla* is similarly
regarded as inferior to the African variety. Brown ebony is a dark,
hard and heavy tropical wood with light brown featherlike
markings. It is sometimes commercially available in fairly large
sizes such as logs a foot or more in diameter and 6 or more feet
in length. It weighs about 80 pounds per cubic foot.
Ebony from Ceylon (*Diospyros ebenum*) very often attains a

89

diameter of 2 feet and a length of between 10 and 15 feet. It is very rare, however, and difficult to secure commercially.

Mozambique Ebony is a term applied to a dark violet or plum-colored hardwood which is also known as *African Blackwood* or *Grenadilla*. It weighs about 54 pounds per cubic foot.

Nigerian Ebony (Diospyros crassiflora) is a dark, fine variety.

Edinam (Entandrophagma angolense) is also known as *Gedu Nohor, Ipaki, Brown "Mahogany", Jebu "Mahogany",* and *Timbi.* The wood is quite hard and has a faint scent when it is carved. It has a reddish-brown color with a striped pattern. Edinam is a tropical hardwood which is native to West Africa. It is moderately priced when available.

Elm is a medium weight, but tough hardwood, which is rather difficult to carve and only occasionally used by sculptors. The color of this wood varies from a light to a dark brown. Elm weighs about 35 pounds per cubic foot. *American Elm (Ulmus americana,* Linn.) is grown most abundantly in the United States east of the Rocky Mountains. It is a tough and heavy wood which is also called *Soft Elm, Water Elm,* and *White Elm. Brown Elm (Ulmus rubra)* is also referred to as *Gray Elm, Red Elm,* and *Slippery Elm. This* variety grows from Canada to the southern part of the United States. It is similarly coarse-grained and hard. The wood is a dark brown color and is moderately priced.

Carpathian Burl or *English Elm (Ulmus campestris,* Linn.) is a light tan to darker brick red hardwood which grows in the Carpathian mountains, England, and France. It is very rarely used sculpturally and is quite expensive when it is available commercially. The importation of this wood into the United States has been banned because of the Dutch elm disease.

Embuia, see *Imbuya.*

Emeri (Terminalia ivorensis, A. Chev.) is also known as *Black Afara, Framerie,* and *Ireme.* This tropical hardwood comes from the African Gold Coast. It is a delicate yellowish to light brown wood with a fine ribbon striping.

English Brown Oak, see *Oak.*

English Elm, see *Elm.*

English Harewood, see *Sycamore.*

English Sycamore, see *Sycamore.*

English Whitewood, see *Sycamore.*

English Yew, see *Yew.*

Epplewood or *Ipilwood* is a beautiful tropical wood which is imported from the Philippine Islands. This exotic warm brownish-violet variety is, however, reputed to be irritating to some carvers who when exposed to the wood, may develop a nasal congestion and the symptoms of hay fever. The wood weighs about 60 pounds to the cubic foot.

Eucalyptus trees make up a group of almost 400 related species, which are mostly of Australian origin. The principal specie,

Blue Gum (Eucalyptus globulus) is native to Australia, but has been transplanted. It grows abundantly on the Pacific Coast of the United States, particularly southern California. This is the species which is generally referred to when eucalyptus is mentioned in North America. The wood is a straw color and is very durable, hard and heavy. It is extremely difficult to season and to carve. Blue gum weighs between 43 and 69 pounds per cubic foot.

Jarrah (Eucalyptus marginata) is a reddish hardwood, native to Australia. The wood is hard and heavy and oily and takes a good polish. It is said to repel termites. Jarrah weighs about 65 pounds per cubic foot. Jarrah shrinks a great deal in seasoning and may check badly if this procedure is not accomplished carefully.

Karri (Eucalyptus diversicolor) is similar to Jarrah, but even harder and possessing a coarser grain. Karri is a reddish-brown, hard, heavy, and compact variety which is also native to Australia. The wood is very durable, but is extremely difficult to carve. It weighs about 63 pounds per cubic foot.

Mountain "Ash" (Eucalyptus regnans) is also called *Argento,* and *Tasmanian "Oak".* The wood is a light tan to golden brown color with a fairly straight grain. It is very hard and quite durable. While this species is extremely abundant in Tasmania and eastern Victoria, it is quite scarce in the United States and very costly when it is commercially available.

European Oak, see *Oak.*

Ewowo, see *Ayous.*

Faux Bois de Rose du Congo, see *Rosewood.*

Faux Rose, see *Rosewood.*

91

Finnish Birch, see *Birch*.

Fir is one of the harder evergreens. The trees are members of the *Abies* genus, and are primarily softwoods which are quite easily carved. Fir is readily available and modestly priced.

Florisa, see *Cativo*.

Flowering Dogwood, see *Dogwood*.

Frake, see *Korina*.

Framerie, see *Emeri*.

French Oak, see *Oak*.

French Rosewood, see *Rosewood*.

Gaboon, see *Okoume*.

Gaboon Ebony, see *Ebony*.

Gaboon Mahogany, see *Okoume*.

Gaboon Wood, see *Okoume*.

Gabun, see *Ebony, Gaboon*.

Gateado, see *Goncalo Alves*.

Gedu Nohor, see *Edinam*.

Genizero, see *Kelobra*.

German Oak, see *Oak*.

Gonçalo Alves (*Astronium fraxinifolium*, Schott) is also referred to as *Gateado*, *Kingwood*, and *Mura*. It is a light to dark brown, beautifully figured hardwood from Brazil and northern South America. The wood is close-grained, hard and heavy, quite durable, and takes a fine polish. It is generally available commercially in large logs. It is not very frequently used for wood carving.

Gonsella, see *Almique*.

Gray Elm, see *Elm*.

Greenheart (*Ocotea rodiaei: Nectandra rodiaei*). Greenheart is an extremely hard, heavy, and tough wood, which is imported from British Guiana and the West Indies. It is related to Myrtle wood.
The colors of this wood vary from a pale emerald green or olive to almost black. Greenheart has a very fine grain. The wood is generally expensive and available in very large logs 12 to 24 feet in length and up to about 2 feet in diameter. The wood weighs from about 65 to 75 pounds per cubic foot. Greenheart should be worked with great caution since some individuals are very

sensitive to this wood. Splinters, particularly, may have a poisonous effect.

Grenadilla, see Ebony.

Guanacaste, see Kelobra.

Guayacan, see Lignum Vitae.

Guinea "Walnut", see New Guinea Wood.

Guinea Wood, see New Guinea Wood.

Gum (Liquidambar styraciflua, Linn.) The gumwoods are light, small-pored southern hardwoods, which are plentiful, but frequently difficult to carve. Many varieties manifest an unfortunate tendency to shrink, warp, and to check in seasoning. The heartwood and the sapwood are usually sold separately as Red Gum (heartwood) and Sap Gum (sapwood).

Red Gum flourishes in many states of the United States, but the major commercially productive areas are in the lower Mississippi Valley area. The wood is also called Hazelwood, Southern Gum, and Sweet Gum. Southern gum is a good carving variety that is also fairly durable. The color of this wood, which resembles walnut, varies from a grayish brown to a reddish brown, with dark streaks. It is a hard, fairly heavy and straight-grained wood which is not very strong physically.

Sap Gum is the sapwood of the same species. The color of this weaker wood is generally a delicate pinkish white. It is both abundant and inexpensive. The seasoned wood weighs about 37 pounds per cubic foot.

Gum, Black (Nyssa sylvatica, Marsh.) is also referred to as Sour Gum and Tupelo Gum. It is not a true gum, but one of the dogwoods. Black gum wood is also distinct from true gumwood. While both are close-grained, heavy, strong, and difficult to season, Black gum is a harder wood. The heartwood is a light brownish color, frequently nearly white.

Black gum weighs about 39 pounds per cubic foot. It grows in the United States from Maine to Florida and westward to Texas.

Gum, Blue, see Eucalyptus.

Gum, Sap, see Gum.

Gum, Tupelo (Nyssa aquatica, Linn.) is also called Bay Poplar, Cotton Gum, Large Tupelo, Tupele Gum, Tupelo, and Water Tupelo. The wood grows in several southern states of the United States

including Kentucky, Mississippi, Virginia, and from Texas up to Illinois. It is a yellowish to brownish streaked hardwood. The grain is generally fine and the wood is both plentiful and inexpensive, but it is light in weight and soft, not strong physically. The wood is paradoxically rather difficult to work. It weighs about 32 pounds per cubic foot.

Hackberry (*Celtis occidentalis*, Linn.) is also called *Sugarberry*. It is a wood which is native to the United States, growing from the New England states south to Virginia and westward to Iowa. Hackberry is a yellowish, rather coarse-grained hardwood, which is not too strong physically. The wood is generally available commercially and inexpensive.

Hard Maple, see *Maple.*

Hard Pine, see *Pine.*

Harewood, see *Sycamore.*

Hazelwood, see *Gumwood.*

Hickory (*Hicoria* or *Carya*) is a wood of many species and varieties which grow abundantly in the eastern part of North America, down to Mexico. The varieties of hickory are all hard and strong woods and all of them are quite difficult to carve. The colors vary from a near white or cream to tan and the darker browns. The wood is generally abundant and modestly priced. Hickory weighs between 40 and 52 pounds per cubic foot. Extreme care must be observed in seasoning hickory to minimize checking and warping, because the wood tends to shrink greatly in drying out.

Holly (*Ilex opaca*, Aiton) is a fine, close-grained, compact, and moderately hard light wood, which is quite easily carved. The wood grows in the United States from the state of Maine to Florida. Holly heartwood is a creamy white or ivory color, with a tendency to spot and to darken or brown on exposure and aging. The wood is frequently quite difficult to secure.

Honduras Cedar, see *Cedar, Spanish.*

Honduras Mahogany, see *Mahogany.*

Honduras Rosewood, see *Rosewood.*

Hornbeam, see *Ironwood.*

Horse Chestnut, see *Buckeye.*

Hungarian Oak, see *Oak.*

Hura (*Hura crepitans*, L.) is also called *Rakuda*. Hura is a very light yellow

colored hardwood from Dutch Guinea. The wood is quite scarce and expensive.

Idaho White Pine, see *Pine.*

Imbuia, see *Imbuya.*

Imbuya (Phoebe porosa, Mez.) is also referred to as *Brazilian Walnut, Canella, Determa, Embuia,* and *Imbuia.* Imbuya is a generally straight-grained, rich yellowish to dark brown hardwood imported from Central and South America, notably Brazil. It is occasionally called Brazilian walnut because of the similarity of its color to true walnut. However, it is softer than black walnut. Imbuya is fairly durable, fine-textured, moderately hard and heavy, but easy to work and capable of taking a fine polish. It is generally available in long logs and thin planks and is not expensive. The wood weighs between 40 and 45 pounds per cubic foot.

Indian Boxwood, see *Boxwood.*

Ipaki, see *Edinam.*

Ipe or *Ipi (Tabebuia,* spp.) is a Brazilian hardwood which is rarely used for carving purposes. The wood varies markedly in color, ranging from a light yellow to dark. It is heavy and resembles greenheart. When available, it is generally moderately priced.

Ipilwood, see *Epplewood.*

Ireme, see *Emeri.*

Iroko (Chlorophora excelsa) is also called *African Teak, Odoum,* and *Oroko.* This West African tropical hardwood varies in color from a fairly light brown to a very rich golden brown. It is similar to teak in its physical characteristics. While it is very durable, it is not as strong as teak. The wood is infrequently available.

Iron Mahogany, see *Lignum Vitae.*

Ironwood is a name which has been used to describe about 75 different species of wood, including about 10 different North American species yielding unusually hard and heavy wood varieties. It has also been used as another name for lignum vitae.

Blue Beech (Carpinus caroliniana, Walt) is a very hard, heavy and tough variety with a nearly white sapwood and a light brown heartwood. This wood, which is very hard, unfortunately has a tendency to check in seasoning and is not durable when exposed to the elements. Seasoned blue beech weighs about 45 pounds per cubic foot. It grows from southern Canada to Florida.

Hornbeam (*Ostrya Virginiana*, Willd.) is also called *Ironwood*. It grows from Nova Scotia to Florida and westward to the Dakotas and Texas. Hornbeam has a reddish-brown heartwood and an almost white sapwood. The wood is close-grained, hard, heavy, very strong, and durable on exposure. Seasoned hornbeam weighs about 51 pounds per cubic foot.

Ita, see *Celtis*.

Itako, see *Celtis*.

Italian Olive Ash, see *Ash, European*.

Italian Walnut, see *Walnut*.

Ivorywood is a term rather loosely applied to several of the rarer African woods which are quite hard and have delicate creamy pink or ivory hues. The true ivorywood (*Balfourodendron riedelianum*) grows in Brazil and is fairly rare. The color, which resembles ivory, is the reason for its name. It is a close, compactly grained wood, weighing between 45 and 52 pounds per cubic foot.

Jacaranda, see *Rosewood*.

Jarrah, see *Eucalytpus*.

Jebu "Mahogany", see *Edinam*.

Jenisero, see *Kelobra*.

Juniper, see *Cedar*.

Kaneelhart (*Licaria cayennensis*) is one of the hardest and heaviest woods known. There are about 40 known varieties of the kaneelhart tree. It is a member of the laurel family and is distantly related to the sassafras tree which grows in the United States. This hardwood is about five times stronger than white oak. It weighs about one third as much as aluminum, but it is nearly half as strong as this metal. Kaneelhart grows in Central America and the northern coast of South America.

Kapok, see *Ceiba*.

Karri, see *Eucalyptus*.

Kelobra (*Enterolobium cyclocarpum*) is also called *Genizero, Guanacaste, Jenisero*, and *Parota*. Kelobra is a tropical brown hardwood with a greenish tint. It grows in the British Honduras, Guatemala, and Mexico. The wood is fairly coarse pored, generally available and moderately priced.

Kewasinga or *Kewazinga* is a Gaboon hardwood which is related to bubinga.

The French group these two woods together and refer to them
as *African Rosewood*.

Kingwood (Dalbergia cearensis, Cucke) is also called *Violetwood.* Kingwood
is a dark violet-brown tropical hardwood from the northern
portion of South America, notably from Brazil. The grain is
generally streaked with light and dark yellow markings. The wood
is quite hard and heavy, rather brittle. It weighs about 75 pounds
per cubic foot. Kingwood is usually available in small logs with a
maximum diameter of about 6 inches. It is fairly rare and expensive.
Kingwood is a name which has also been used to describe other
woods such as Gonçalo Alves.

Koa (Acacia koa, Gray) is a light-weight exotic wood which is native to the
the Hawaiian Islands. It is quite hard and durable and has a
beautiful golden brown color with an attractive grain. Koa is
generally available but expensive.

Koko (Albizzia lebbeck) is also called *Kokko, East Indian Walnut,* and *Lego
wood.* Koko is a hard, dense, close-grained dark brown and gold
tropical hardwood, with large pores which is imported from
Burma, Ceylon, and India. It is usually available in log form and
is quite expensive.

Kokrodua, see *Afrormosia.*

Korina (Terminália superba) is also referred to as *Afara, Frake, Limba,* and
Offram. Korina is a naturally blond wood which is imported
from the Belgian Congo. It is moderately hard and carves well.
Korina is generally available and moderately priced.

Kwi, see *Bosse.*

Lacewood (Cardwellia sublimis) is a light pinkish Australian wood with a
silvery sheen. It is also called *Australian Silky "Oak", Queensland
Silky "Oak", Selano,* and *Silky "Oak".* The wood is quite scarce
and expensive when it is available.

Lagos, see *Ebony, Gaboon.*

Lancewood is a fairly rare wood which is similar to lemonwood, but which
is physically stronger and more resilient. Its physical strength
is greater than degame, but a bit less than hickory.

Laredo, see *Capome.*

Largetooth Aspen, see *Poplar.*

Large Tupelo, see *Gum, Tupelo.*

Laurel is a name applied botanically and/or locally to a number of trees.

California Laurel (Umbellularia californica) is also referred to as *"Acacia" Burl, Baytree, California Laurel, Mountain Laurel, Myrtle, Oregon Myrtle,* and *Pepperwood.* The heartwood is a light, but rich brown color and the sapwood is a lighter brown. California laurel grows on the Pacific coast of the United States, particularly in Oregon and northern California. The wood is hard, heavy, and physically strong and it takes a beautiful polish. However, the green wood may check and warp in seasoning, so that this has to be done very carefully. The seasoned wood weighs about 40 pounds to the cubic foot. Laurel is an excellent carving material, but it is quite rare, difficult to secure commercially, and fairly expensive when it is available.

Madrona (Arbutus menziesii, Pursh.) is also called *Madrone, Madrono,* and *Madrona Laurel.* It also grows on the Pacific coast of North America, from British Columbia to southern California. Madrona heartwood is a beautiful reddish color and the sapwood is a bit pink. It is a close-grained, hard and heavy wood, which, while physically strong, checks quite badly in seasoning. The seasoned wood weighs about 43 pounds per cubic foot.

Laurel, East Indian (Terminalia tomentosa) is also called *East Indian "Walnut".* This gray to brown striped tropical hardwood is imported from Burma and India. It has a coarse grain and is somewhat brittle. The wood is fairly scarce and expensive.

Lega, see *Koko.*

Lemonwood (Calycophyllum candidissimum) is also called *Degame.*

Lemonwood is a yellowish or creamy-white, fairly straight-grained hardwood which is occasionally used for carving. Central America and Cuba are the main sources of this wood, which is generally available in large logs about 12 inches in diameter and 12 feet in length. The wood is heavy and strong and usually expensive. It is similar to hickory in its toughness and is difficult to carve.

Leopardwood, see *Snakewood.*

Lerado, see *Capome.*

Letterwood, see *Snakewood.*

Lignum Vitae or "wood of life" is undoubtedly the heaviest, one of the hardest and densest commercial varieties of wood available. The wood weighs about 85 pounds per cubic foot. It is frequently

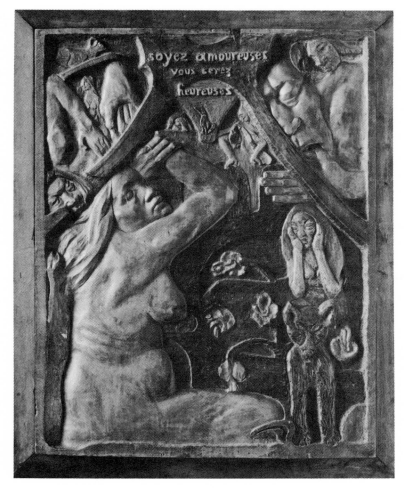

"SOYEZ AMOUREUSES VOUS SEREZ HEUREUSES," by Paul Gauguin.
Polished and polychromed linden wood. 47⅛ inches high.
A self-portrait of the artist, who was primarily a painter, may be seen in the upper right
hand corner of this rather primitive relief. Gauguin regarded this carving, with its symbolic
allusions to human emotions and suffering, as his greatest piece of sculpture.

Museum of Fine Arts, Boston
Arthur Tracy Cabot Fund

referred to as *Guayacan, Iron Mahogany,* and *Iron Wood.* Lignum vitae is secured principally from two species, *Guaiacum sanctum* and *Guaiacum officinale.* A third species, *Guaiacum arborium,* supplies a similar wood.

The extreme hardness of lignum vitae makes it exceedingly difficult to carve, and many sculptors emphasize the hard nature of the wood by a rough, broad treatment, securing rugged and stonelike effects. The wood is close-grained and compact, extremely durable, but is occasionally somewhat brittle in carving, and some soft spots may be encountered. Lignum vitae has a fine grain, a mild scent, and is very oily or waxy. This latter characteristic enables it to take a very high polish. The heartwood varies from a light olive green to a deep brown or near-black color. Young specimens of heartwood are usually a rich yellow-brown color; older specimens approach black.

The lignum vitae trees are gnarled, low-growing trees, reaching a maximum height of about 25 feet and a maximum diameter of approximately one and a half feet. The wood is imported from Cuba, Haiti, Jamaica, Puerto Rico, the Bahamas, Nicaragua, and South America. Some wood is secured from semi-tropical Florida. Lignum vitae is generally available in logs from about three inches to one and a half feet in diameter and up to 10 feet in length. It is a fairly expensive wood, but a very popular wood with sculptors.

Linden, see *Basswood.*

Live Oak, see *Oak.*

Locust, Black, (*Robinia pseudoacacia,* Linn.) is also called *Yellow Locust.* This yellow-green to brownish, tough and compact hardwood comes from the southern parts of the United States. It is very durable and has an attractive but prominent grain. Care should be observed, however, in selecting this wood, which very frequently has defective portions. The wood is not readily available. It is difficult to carve, but takes a good finish. Seasoned locust wood weighs about 45 pounds per cubic foot.

Macacauba (*Platymiscium,* spp.) is also known as *Brazilian Padouk, Maca Wood, Monkey Wood,* and *Quira.* It is a rare and expensive reddish-brown tropical hardwood from Central America and the northern portions of South America, particularly Brazil. Macacauba

has a rather irregular pattern and is occasionally striped. It is rarely used sculpturally.

Macassar Ebony, see *Ebony.*

Maca Wood, see *Macacauba.*

Macaya or *Macayo (Andira inermis)* is available in many varieties. It is a coarse-grained, but hard, heavy and durable wood with beautiful figuring. Macaya has the appearance of old mahogany. The most common species of this wood flourishes in and is secured from Mexico. It is, however, quite difficult to carve and is infrequently used for sculpture.

Madagascar Palisander, see *Rosewood.*

Madagascar Rosewood, see *Rosewood.*

Madrona, see *Laurel.*

Madrona Laurel, see *Laurel.*

Madrono, see *Laurel.*

Magnolia (Magnolia acuminata, Magnolia grandiflora, Linn.) is also called *Cucumber Tree.* The wood is similar to whitewood, which it resembles, and also to yellow poplar although it has more dark streaks than poplar.

Magnolia wood is rather soft and light. While it is fairly durable, it is not physically strong. The heartwood is a brownish-yellow color. The wood is fairly abundant and not expensive. It is, however, infrequently used for carving. Seasoned magnolia weighs about 29 pounds per cubic foot.

Mahogany is a fairly inexpensive hardwood, which enjoys an excellent reputation among sculptors. The term has, unfortunately, been very loosely applied to many wood varieties which are not true members of the mahogany family. All true mahoganies belong to the *Meliaceae* family, genera *Swietenia* or *Khaya.*

The mahoganies are strong woods, of medium weight, and they have great beauty and durability. They are excellent for carving, but this requires experience and care, since they are somewhat brittle and manifest a tendency to splinter. Raw, unfinished mahogany varies from an ocherish color to a golden brown. The natural colors of the finished woods are rich, warm golden to reddish browns.

Mahogany pores vary from medium to large and are generally well spaced, but frequently conspicuous. The woods are fine

grained and have a smooth, silky appearance when they are well finished. They are capable of taking a very high polish.

Mahogany is highly resistant to atmospheric humidity and there is a minimum of danger of its warping, swelling, or shrinking. The woods are also highly resistant to mold and decay, even in tropical climates.

Mahogany trees frequently grow to a tremendous size, occasionally reaching between 6 and 10 feet in diameter and 150 feet in height. The mahoganies are tropical woods, secured mainly from Africa, Central and South America, and the West Indies. They are quite plentiful and are generally available in planks, blocks, and large logs.

There are several varieties ranging from relatively soft woods to harder types, but only three commercially important species. The West Indian *Swietenia mahogani* is marketed as *Cuban, Santo Domingan,* or *Spanish* mahogany. Another species, *Swietenia macrophylla,* grows in Brazil, Guatemala, Honduras, Nicaragua, Panama, Peru, and northern South America. *Honduras mahogany* carves like walnut. The principal African species, *Khaya ivorensis,* comes from the Gold and Ivory Coasts, Nigeria, and nearby regions of equatorial West Africa, and is known collectively in America as *African mahogany.*

Santo Domingan mahogany is one of the hardest and heaviest varieties. The wood is rich and close-grained, with a silky texture. When freshly cut, it is a yellowish white, but changes to a golden brown or a deep reddish brown. It is rather difficult to carve. Cuban mahogany is densely grained and is regarded by many sculptors as the hardest and heaviest variety of mahogany. African mahogany is one of the softest varieties. The wood has larger pores than American mahogany and is luxuriously figured with stripes, mottles, and exotic swirls. When freshly cut, it is a pinkish color, which changes to a pale golden brown. African mahogany carves very well. Tropical American mahogany is generally straight grained and more mellow in appearance than West Indian mahogany. The wood is yellowish white to pink when freshly cut, but changes to a rich, golden brown. Peruvian and Amazon, or Brazilian mahogany comes from the upper regions of Brazil and Peru.

Philippine mahogany is a term which has been too loosely applied to a large group of Philippine woods which are not even remotely related to the true mahoganies. The name is applied to at least a half-dozen species of the dipterocarp family. Most of the woods referred to as Philippine mahogany are fairly soft and carve well, but they generally possess the undesirable characteristics of losing color or bleaching on prolonged exposure to light and are also less durable on exposure to atmospheric humidity than are the true mahoganies. The woods which are marketed as Philippine mahoganies are usually very varied in color and are fairly plain and stringy, with larger pores and a coarse appearance than true mahoganies. They include the softer *Shorea* species which are light colored to a reddish brown, and also the *Parashorea* and *Pentacme* species. These woods are generally given a deceptive mahogany finish when they are used commercially and weakly resemble true mahogany.

The following are the varieties that are marketed as Philippine mahoganies:

Almon (Shorea almon, Foxw.) is a creamy straw colored Philippine hardwood which is occasionally sold as *White Lauan.* It carves well, but is rather stringy. Almon takes a good finish and is rather inexpensive. *Bagtikan (Parashorea plicata,* Brandis) is a fairly rare Philippine hardwood which is only occasionally available in lumber form.

Red Lauan (Shorea negrosensis, Foxw.) is a red to brown colored striped wood variety with large pores and a coarse texture. This wood is quite abundant and inexpensive.

Tangile (Shorea polysperma, Merr.) is also known as *Tanguile.* It is a dark reddish-brown variety with ribbon striping. Tangile is light weight and moderately hard. It is a fairly abundant species and the wood is relatively inexpensive when available.

White Lauan (Pentacme contorta, Merr.) is a light grayish brown to reddish brown, coarse textured Philippine variety. It is relatively inexpensive when it is available.

"Mahogany" Demerara, see *Andiroba.*
"Mahogany", Pink, see *Agba.*
"Mahogany", White, see *Primavera.*

Majagua is a hard, greenish to blue-gray Cuban hardwood which is used
primarily for the manufacture of baseball bats.

Makore (Mimusops heckelii) is also referred to as *African Cherry, Baku,
Cherry Mahogany, Makora,* and *Makori.* This beautifully figured
fine textured tropical hardwood which closely resembles a
close-grained mahogany, flourishes in the western portion of
Africa, notably Ghana and Nigeria. The color of Makore wood
varies from a pinkish brown to a deep blood-red brown. The wood
is moderately priced and occasionally available in log form. It
weighs about 40 pounds per cubic foot.

Malabar or *Malobar,* see *Rosewood.*

Malacca wood is best known by its use in the manufacture of fine canes.
The wood is very rarely used sculpturally. It is secured from an
Asiatic rattan palm.

Manggasinora, see *Sonora.*

Mansonia (Mansonia altissima, A. Chev.) is also erroneously called *African
Black Walnut* due to a similarity of color of heartwood and
sapwood. It is also called *Aprono, Ofun,* and *Opruno.* Mansonia
grows on the west coast of Africa, notably Ghana, Ivory Coast,
and Nigeria. The heartwood varies markedly in color from a light
yellowish-brown to a violet-brown. However, the colors which
are apparent on freshly cut surfaces gradually fade on exposure to
the air and become a fairly uniform dark violet-brown. Mansonia
is a fine and smooth textured tropical hardwood which carves
very well and takes an excellent finish. The wood is also quite
resistant to decay. It is generally available and moderately priced.
Mansonia weighs about 37 pounds per cubic foot.

Maple has many species and these are generally classed with the hardwoods,
although some of the varieties are rather soft. Maple is a
close-grained wood with a fine and compact texture. *Bird's Eye
Maple* or *Hard Maple (Acer saccharum,* Marsh) is also called
Northern Maple, Rock Maple, and *Sugar Maple.* The name *Bird's
Eye* refers to an ornamental graining found mostly in the hard
varieties. It is native to the northwestern portions of the United
States and Canada. The heartwood varies from an almost white or
cream color to a light brown to reddish brown. Dark, but small
specks and discolorations make securing a perfect light wood mass
a problem. It is a heavy, strong and uniformly textured wood

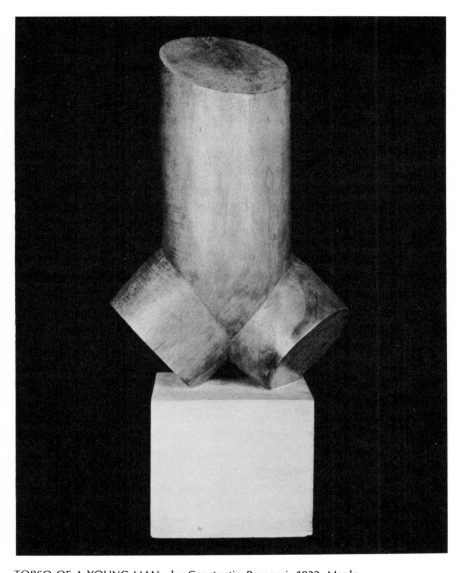

TORSO OF A YOUNG MAN, by Constantin Brancusi. 1922. Maple.
19 inches x 12¼ inches x 6¾ inches,
mounted on a limestone base 7 inches x 8 inches x 7⅛ inches.
A fine example of three-dimensional abstract expressionism in which the natural forms are
reduced to basic geometric cylindrical masses.

Philadelphia Museum of Art
The Louise and Walter Arensberg Collection

105

which is generally available and moderately priced.

Oregon Maple, (*Acer macrophyllum,* Pursh.) is also called *Big Leaf Maple.* This variety flourishes on the west coast of the United States and southwestern Canada. It is, however, a weaker physical variety.

Silver Maple (*Acer saccharinum,* Linn.) or *Soft Maple* is very similar to bird's eye maple, but it is markedly softer physically. Varieties of maple vary in weight from about 39 pounds to 49 pounds per cubic foot.

Maracaibo Boxwood, see *Boxwood,* West Indian.

Marblewood, see *Ebony, Macassar.*

Moboron, see *Agba.*

Monkey wood, see *Macacauba.*

Morado, see *Amaranth.*

Mountain "Ash", see *Eucalyptus.*

Mountain Laurel, see *Laurel.*

Mountain Oak, see *Oak.*

Mozambique Ebony, see *Ebony.*

Muninga, see *Padouk.*

Mura, see *Goncalo Alves.*

Myrtle Wood, see *Laurel.*

Narra (Pterocarpus indicus, Pterocarpus echinatus) is a hardwood from the Philippine Islands and the Dutch East Indies, which is related to the Andaman Islands' *Padouk.* The colors of this wood vary from a golden yellow to a rich reddish-brown. The wood is hard and quite durable. It is not always available commercially and is rather expensive.

New Guinea Wood (*Dracontomelum magiferum,* Blume) is also called *Guinea Wood* and *Guinea "Walnut".* This tropical wood, which is native to New Guinea and the Philippine Islands resembles paldao in color. It is a striped and mottled hardwood which is generally available, but expensive to acquire.

Nigerian Cedar, see *Agba.*

Nigerian Ebony, see *Ebony.*

Nigerian Golden "Walnut", see *Tigerwood.*

Northern Maple, see *Maple.*

Northern Yellow Birch, see *Birch.*

Oak is a hard, tough, close but coarse grained, durable, and beautiful wood, which has been used extensively in the past for sculpture. Unfortunately, however, all of the varieties of oak are subject in seasoning to a warping and checking which may be quite severe. The woods are capable of taking a high polish and are not very subject to insect attack. While oak is quite hard, it is excellent for general carving and it is an ideal wood for broad, strong designs. There are many varieties of oak, including *American Oak,* a rather broad term embracing more than 50 species which grow in the United States, imported varieties such as *English Brown Oak* and oak from other countries. However, not all kinds are equally suitable or desirable for sculptural use.

English Brown Oak (Quercus robur, L.Q., Quercus sessiliflora, Salis.) is also called *European Oak,* and *Pollard Oak.* This excellent native English hardwood varies in color from a light tan to a dark brown. The wood is generally available, but rather expensive. The term *European Oak* is a name given oak grown in different countries, which are botanically identical with English brown oak , but are generally lighter in color. The color variations in the same species are due primarily to differences in climate and in soil. The country in which the oak is grown is usually used to label or to name the wood: *Austrian Oak, French Oak, German Oak, Hungarian Oak, Russian Oak,* and so forth.

Domestic oak can be roughly divided into three major groups: white oak varieties, red or black oak, and live oak.

Live Oak (Quercus virginiana) is a hard variety which is close grained and quite strong structurally, but relatively scarce.

Red Oak (Quercus rubra) is a hard, heavy, porous and strong oak which flourishes along the eastern United States and in the central states. It has a tendency to check in seasoning and is fairly coarse. The wood is also referred to as *American Oak.* It is not quite as good as white oak for carving purposes although white oak and red oak are similar physically. They are also in plentiful supply and are generally moderately priced. *White Oak (Quercus alba,* Linn.) is strong, hard, and heavy, and takes a good polish, but care has to be exercised in seasoning the wood or a serious checking can result. It is native to the eastern United States and is also called *American Oak.*

107

The Eastern or mountain oak varieties are generally considered to be the finest for carving purposes.

Oak heartwood varies from a creamy white or yellowish color to a dark brown.

The color of most varieties can be darkened, if this is desired, by the application of concentrated ammonia.

Oak is very frequently finished, subsequent to carving and possible sanding, by oiling or waxing.

Seasoned oak heartwood varies in weight between 43 and 48 pounds per cubic foot.

"Oak" Tasmanian, see *Eucalyptus.*

Obeche, see *Ayous.*

Obobo, see *Bosse.*

Odoum, see *Ceiba* also *Iroko.*

Offram, see *Korina.*

Ofun, see *Mansonia.*

Ogechi, see *Capome.*

Ohia, see *Celtis.*

Ohio Buckeye, see *Buckeye.*

Ojoche, see *Capome.*

Okoume (*Aucoumea klaineana,* Pierre) is also called *Angouma, Gaboon, Gaboon Mahogany,* and *Gaboon Wood.* Okoume is a light reddish-brown wood from the western part of Africa. It is a relatively soft hardwood and is light in weight, weighing only about 25 pounds per cubic foot. However, it is quite strong physically. The wood is straight grained and it is relatively inexpensive when available. It works well with sharp tools.

Okpo, see *Ayous.*

Olivewood (*Olea europaea,* Linn.) is an excellent carving wood, with a yellowish-brown to rich, greenish-brown color. It is native to southern Europe, particularly Italy. The wood has an unfortunate tendency to brittleness, but takes detail very well. Olivewood is hard and heavy and close-grained. It is usually quite expensive when it is available commercially.

Olon, see *Avodire.*

Opepe (*Sarcocephalus diderrichii,* DeWild) is also referred to as *Abiache.* Opepe is a grayish-white to yellowish-pink or orangy African hardwood from Ghana and southern Nigeria. The wood is similar

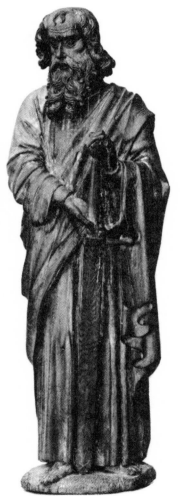

ST. PAUL. French, Gothic. End of the 15th Century.
Probably School of the Loire. Oak, originally painted.
44½ inches high.
While this impressive carving was originally painted, no
trace of color remains on the polished oak. The head is
solid, but the back of the body has been hollowed out
as were many medieval wood carvings of figures, to
minimize the possibility of cracking.

The Metropolitan Museum of Art
Gift of J. Pierpont Morgan

109

to mahogany physically, particularly in pattern, and is generally moderately priced when available.

Opruno, see *Mansonia*.

Oregon Maple, see *Maple*.

Oregon Myrtle, see *Laurel*.

Oriental "Walnut", see *Oriental wood*.

Oriental wood (Endiandra palmerstoni) is also called *Australian "Laurel"*, *Australian "Walnut"*, and *Oriental "Walnut"*. This Australian hardwood varies in color from a tan or light brown to a darker brown with fine short brown streaks. The wood is quite firm, and carves well, and takes a good polish. It is generally available, but expensive.

Oroko, see *Iroko*.

Padouk is a family of four attractive and popular tropical hardwoods.

> *African Padouk (Pterocarpus soyauxii,* Taub) is also called *Corail*. It is a golden-red to blood-red, frequently striped wood, which is used largely for decorative purposes. The wood is very durable and comes from the western coast of Africa. African padouk is generally scarce and expensive.

> *Andaman Padouk (Pterocarpus dalbergioides,* Roxb.) is also called *Vermilion Wood*. This very rare, golden brown to wine-red colored hardwood comes from the Andaman Islands and resembles ebony in its working qualities. It frequently possesses narrow striping or dark veins. When it is available commercially, usually in small log form, it is quite expensive.

> *Angola Padouk (Pterocarpus angolensis)* is also called *Muninga*. It is a golden to dark brown hardwood which comes from Eastern Africa. The wood is moderately hard, but quite durable. Angola padouk is also generally scarce.

> *Burma Padouk (Pterocarpus macrocarpus,* Kurz.) Burmese padouk is also referred to as *Vermilion Wood*. It is considered to be the most attractive of the padouk varieties. It is a firm tropical hardwood which is generally available in large log form, but is also expensive. Burmese padouk weighs between 43 and 57 pounds per cubic foot.

Paldao (Dracontomelum dao) or *Dao wood* is a very fine gray to red-brown hardwood which is imported from the East Indies and the

110

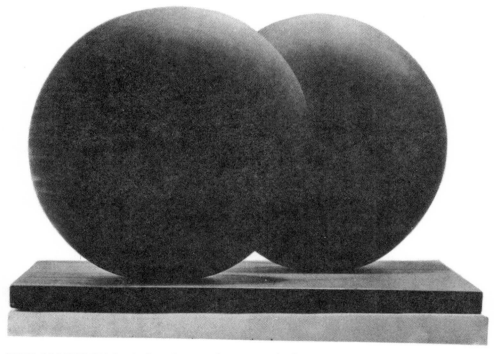

DISCS IN ECHELON, by Barbara Hepworth. 1935. Padouk wood. 12¼ inches high.

Philippine Islands. It is somewhat similar to walnut in color and
figuring and is generally available in large logs and in lumber form.

Palisander, see *Rosewood*.

Palo Blanco means "white wood" and the name is rather loosely applied to
many woods of different species which are native to Central and
South America. The true *Primavera* is quite durable, whereas many
of the others manifest a tendency to warp markedly in drying.
See *Primavera*.

Palo Morado, see *Amaranth*.

Palo Rosa, see *Peroba, Red*.

Palosapis, see *Bella Rosa*.

Parota, see *Kelobra*.

Partridge Wood, see *Ebony*.

Pearwood (Pyrus communis, Linn.) is also called *Pear Tree*. Pear is a light,
rose-tinted, creamy colored wood which grows in France,
Germany, and the United States. It is close, fine and even grained
and is fairly soft. Pearwood carves very well, permitting delicate
details. The imported varieties from France and Germany are
superior to the domestic pearwood grown in the United States for
sculptural use. The wood is generally available commercially in
lumber form and in small logs and may be expensive. Pearwood
weighs about 43 pounds per cubic foot.

Pecan (Carya illinoensis) is a member of the same family as hickory. It is a
hard and heavy, close-grained, but rather brittle wood which
flourishes in the southern United States from Mississippi to Mexico.
The heartwood varies from a light brown to a darker reddish-
brown color, which is frequently streaked. It is usually available
at moderate cost. The seasoned wood weighs about 48 pounds per
cubic foot.

Pencil Cedar, see *Cedar*.

Pepperwood, see *Laurel*.

Pequa or *Piqua*, see *Bosse*.

Pernambuco is a rich, bright reddish South American tropical hardwood
which is not frequently used for wood carving.

Peroba Amarella, see *Peroba, White*.

Peroba Branca, see *Peroba, White*.

Peroba, Red (Aspidosperma polyneuron) is also known as *Palo Rosa*, and
Peroba Rosa. It is a delicate rose-colored, but streaked, Brazilian

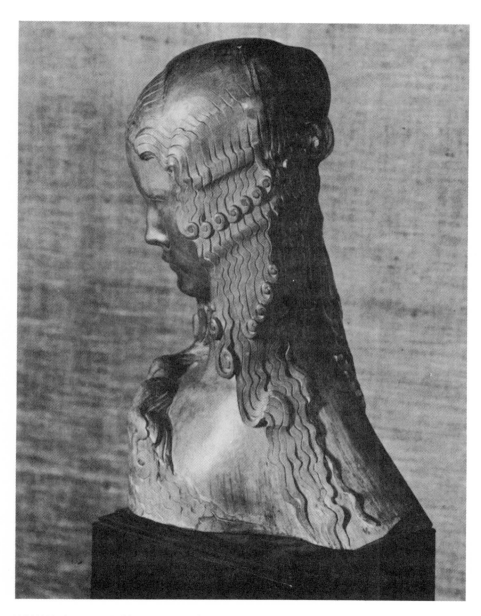

MAMUA, by A. J. Oakley. Pearwood.
19 inches x 8 inches x 11½ inches.

113

hardwood. Red peroba has a fine and even texture and is fairly heavy and durable. The wood, which weighs about 45 pounds per cubic foot, is generally available and moderately priced.

Peroba, Rosa, see *Peroba, Red.*

Peroba, White (Paratecoma peroba, Kuhl.) is also called *Peroba Amarella* and *Peroba Branca.* It is an olive-green to golden tropical hardwood which is grown in Brazil. The wood is fine-grained and is supposed to be stronger physically than teakwood. It is fairly rare and expensive.

Persimmon (Diospyros virginiana) is a tough hardwood which grows in the central and southern United States. It is a member of the ebony family. Persimmon heartwood is very close-grained and varies in color from a light striped brown to an almost black color. The wood is infrequently available. It weighs about 59 pounds per cubic foot.

Philippine Mahogany, see *Mahogany.*

Pine is a term which is applied to many light colored and even-grained softwoods. There are about forty varieties of pine in the United States. Some of these are quite soft, others are of medium hardness, and many types are quite resinous. The colors vary from a straw-white to a reddish-brown. Pine carves quite easily and it is frequently recommended as a 'first-wood' for students just beginning to carve. The wood, however, has a tendency to splinter quite easily and to check and is, therefore, recommended for larger works, broadly treated.

Knotty Pine (Pinus monticola) is also called *Idaho White Pine.* It is a light and soft, but rather straight-grained and knotty wood from Idaho, Montana and Washington. The wood is abundant and moderately priced.

Soft Pine is a pale, yellowish-white, clean, and easily worked, but not very strong wood, which is relatively free from knots and resin. It is usually available in large pieces.

Sugar Pine is an excellent, uniformly grained softwood which is highly recommended as a beginning wood for the student wood carver. The wood generally has an even cellular structure and an absence of the perplexing hard and soft streaks present in many other wood varieties. The fibers of sugar pine tend to hold together fairly well, even when fine carving is performed and the

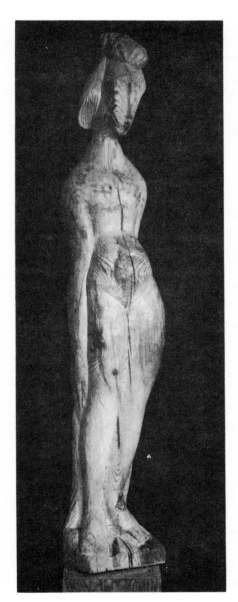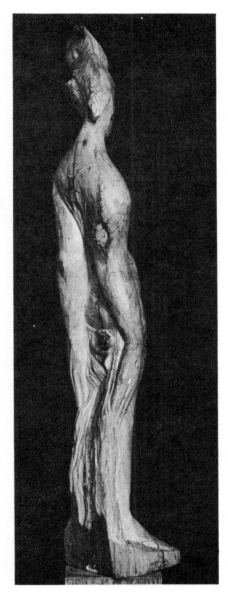

SALAMMBO, by José de Creeft. A direct carving in Georgia pine. 80 inches high.

Collection Jules Campos

115

wood can also be cut cleanly and easily with the grain or across the grain.

Sugar pine is commercially available in fairly large pieces as much as 4 inches in thickness and 24 inches in width.

Hard Pine is strong physically, but resinous.

Norway Pine is the hardest variety and weighs about 47 pounds to the cubic foot.

Piqua, see *Bosse.*

Plane Tree or *Plane Wood,* see *Sycamore.*

Plumwood is occasionally used for carving. The wood is quite soft and it permits a delicacy of detail. Imported plumwood is superior to the domestic varieties.

Pollard Oak, see *Oak.*

Poplar is the name given to many woods, members of the *Liriodendron* and *Populus* species. The varieties are invariably soft, light, and rather weak woods, varying in color from the light yellowish to greenish brown heartwood of *Liriodendron tulipifera,* Linn., which is also known as *Tulip Tree, Whitewood,* and *Yellow Poplar,* to the varieties with darker brown heartwood such as *Populus grandidentata* or *Largetooth Aspen,* and *Populus deltoides* or *Cottonwood.*

Whitewood is an abundant native American wood with a fine, straight grain, which is excellent for carving purposes. It tends, however, to grip the chisel. It also has the disadvantageous characteristic of being a fairly fragile wood that does not wear well and which tends to bruise quite easily.

The varieties of poplar are abundant in the United States and Canada and are inexpensive.

Primavera (*Tabebuia* or *Cybistax Donnell-Smithii,* Rose) is also known as *Durango, Palo Blanco, San Juan,* and "White Mahogany". Primavera is a blond or creamy-white tropical hardwood with a beautiful, fine, straight grain, resembling that of mahogany. It is moderately light weight, carves well and is fairly durable. The wood weighs between 30 and 37 pounds per cubic foot.

Primavera is imported from Mexico and Central America, and is usually available in logs up to about 8 inches in diameter.

Princewood, see *Canaletta.*

Purpleheart, see *Amaranth.*

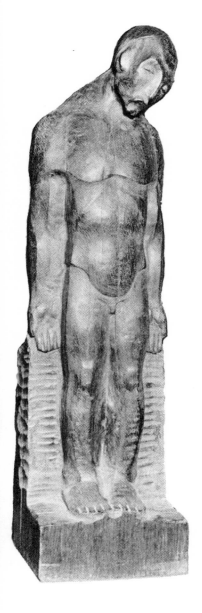

"ECCE-HOMO," by Aaron J. Goodelman.
Purpleheart wood. 17 inches high.

Collection Dr. & Mrs. S. Saul

117

Quebracho (Schinopsis, spp.) is a yellowish to brownish hardwood which is native to Argentina, Brazil and Paraguay. In Argentina the wood is also called *Ironwood* and *Red Lignum Vitae.* It is one of the hardest and heaviest woods known. Quebracho is very strong physically, but it is also quite brittle and difficult to work. The wood is generally available in the form of small logs. It weighs between 70 and 80 pounds per cubic foot.

Queensland Silky "Oak", see *Lacewood.*

Quen Quen, see *Chen Chen.*

Quira, see *Macacauba.*

Rakuda, see *Hura.*

Ramon, see *Capome.*

Rauli (Nothofagus procera) is a brown to cherry-red Chilean wood which possesses many of the physical properties of beechwood. It is used quite extensively in Chile, but is infrequently available in the United States.

Redbark, see *Afrormosia.*

Red Birch, see *Birch.*

Red Cedar, see *Cedar.*

Red Elm, see *Elm.*

Red Gum, see *Gumwood.*

Red Lancewood, see *Beefwood.*

Red Lignum Vitae, see *Quebracho.*

Red Oak, see *Oak.*

Redwood or *Sequoia* trees grow only in California. There are two species: the common redwood, *(Sequoia sempervirens),* which is noted for its lumber, and the big tree *(Sequoia washingtoniana),* which is noted for its great size.

Redwood is an aromatic and quite compact wood, with a fine coarse texture and a straight to parallel graining. The wood is light in weight and not too strong. It is fairly soft and easily worked, but is somewhat splintery although it is capable of a good polish and is fairly durable. It has not been used extensively for carving purposes.

The color of sequoia heartwood varies from a pale cherry or pink to a deep reddish brown. It is available in large sizes and is not a costly wood. Seasoned redwood weighs about 26 pounds per cubic foot.

Rio Rosewood, see *Rosewood.*

Rock Maple, see *Maple.*

Rosewood is an even-textured, heavy, smooth, scented tropical hardwood whose weights vary between 48 and 70 pounds per cubic foot. *Bubinga (Guibourtia demeusii)* is a reddish, fine-grained, streaked, durable and hard West African variety, which is usually available in very large logs up to as much as 10 tons in weight. The variety itself weighs about 58 pounds per cubic foot. It grows most abundantly in the Cameroons and Gaboon, and is also referred to as *African Rosewood, Akume, Bois de Rose d'Afrique, Faux Bois de Rose du Congo,* and *Kewazinga.*

Brazilian Rosewood (Dalbergia nigra) is also called *Bahia Rosewood, Jacaranda, Palisander,* and *Rio Rosewood.* Brazilian rosewood is an extremely fine and even textured tropical hardwood with a beautiful appearance. It is quite fragrant when it is freshly cut. The wood is a dark reddish to chocolate brown, streaked with black or yellow. Huge blocks, planks and logs of this wood are generally available, but are costly to acquire. It carves well and takes a fine polish. Occasional allergic skin reactions in the form of rashes have been caused by exposure to Brazilian rosewood. *Mexican Rosewood* is also called *Balsamo.*

East Indian Rosewood (Dalbergia latifolia) comes from Ceylon and southern India. The wood is also known as *Blackwood, Bombay Rosewood,* and *Malabar.* This tropical variety varies in color from a light yellow or rose to dark violet and an almost black and frequently has a striped yellow or red graining. It is very hard and exceptionally durable, requiring very sharp cutting instruments. The wood, while generally plentiful, is fairly expensive. It weighs about 53 pounds per cubic foot.

Honduras Rosewood (Dalbergia stevensonii) is a light colored variety of rosewood from Central America, notably British Honduras. The color of this wood varies from a pinkish brown to violet, streaked with light and darker bands. It is quite coarse-textured, fairly hard, and heavy, weighing between 60 and 70 pound per cubic foot. Honduras Rosewood is generally scarce commercially and also fairly expensive. The variety does not take a high polish. *Madagascar Rosewood (Dalbergia greveana),* also called *Faux Rose, French Rosewood,* and *Madagascar Palisander,*

119

comes from the island of Madagascar off the coast of east Africa. It has a pinkish-brown color and darker red lines or stripes. The wood is very hard, difficult to secure, and expensive. It is lighter in color than Brazilian and East Indian rosewood , and the average size of the logs is also smaller.

Rum Cherry, see *Cherry.*

Russian Oak, see *Oak.*

Sabicu (Lysiloma sabicu) is a tough and durable tropical hardwood which is imported from Central America and Cuba. It has a dark red to brown, coppery-tinged heartwood, which is occasionally faintly streaked. It is a very close-grained, hard, and heavy. The wood is not used extensively in this country at the present time, either for carving or for furniture. Sabicu weighs about 55 pounds to the cubic foot. It is generally available in fairly large, square cut logs, 7 to 10 feet in length and 12 to 30 inches in width, and is relatively inexpensive.

Sabicu seasons slowly, shrinking very little in the process.

Samba, see *Ayous.*

Sandalwood (Amyris balsamifera) is a hardwood which comes from northern South America and from the West Indies. It is a scented, streaky yellowish to brownish tropical wood with a close, straight grain. Sandalwood is relatively easy to carve and takes a good finish. While the wood is rather brittle, it is strong physically and durable, and is available in small logs. The wood weighs about 60 pounds to the cubic foot.

San Domingan Satinwood, see *Satinwood.*

San Juan, see *Primavera.*

Santo Domingan Satinwood, see *Satinwood.*

Santo Domingo Mahogany, see *Mahogany.*

Sapele (Entandrophragma cylindricum) is also called *Aboudikrou, Sipo,* and *Tiama.* This tropical west African striped hardwood comes from the Ivory Coast and Nigeria and is a dark reddish-brown color. Much care must be exercised in seasoning Sapele which tends to warp very badly as it dries. It can be satisfactorily carved, but is harder and tougher to shape than African mahogany. The wood weighs between 35 and 40 pounds per cubic foot, is generally available commercially, and is moderately priced.

Sassafras wood is secured from several varieties of the laurel family. These native American woods grow east of the Rocky Mountains from the New England states southward to Florida. Sassafras is a light and soft hardwood which is durable, but not physically strong. The wood may check in drying. The heartwood is slightly aromatic and has a delicate brown color. Seasoned Sassafras wood weighs about 31 pounds per cubic foot. It is generally available commercially and is moderately priced.

Satinwood is an exotic, scented wood with beautiful, ornamental graining. *Brazilian Satinwood* (*Euxylophora paraensis,* Huber.) is a light yellow to golden-colored, hard, but easily worked variety, weighing about 56 pounds per cubic foot. It is occasionally called *Canarywood* because of its yellow color, which is generally marked with dark streaks. It is also referred to as *Amarello*. *Ceylon Satinwood* (*Chloroxylon swietenia*) is also known as *East Indian Satinwood*. This fine tropical hardwood is very decorative in appearance, with a pale golden to dark brown color and varied graining. The wood is toxic. Ceylon satinwood is quite dense and has the undesirable tendency of checking in seasoning. It weighs about 50 to 65 pounds per cubic foot. The wood is usually available in large log form, but it is an expensive wood to acquire. *Santo Domingan Satinwood* (*Zanthoxylum flavum,* Vahl.) is also called *San Domingan Satinwood* and *West Indian Satinwood*. It is imported from the British Honduras and from Puerto Rico. The wood is a beautifully decorative hardwood with a lustrous golden color and it is generally regarded as the finest of the satinwood varieties. It is fine grained and heavy, carves well, and takes a fine polish. The wood is usually available in small log form, but is rather expensive. It weighs between 50 and 68 pounds per cubic foot.

Selano, see *Lacewood.*

Sen (*Kalopanax ricinifolium*) is also referred to as *Castor Arabia*. It is a Japanese wood of medium hardness and weight. The heartwood is a pale greenish-brown. Sen tends to shrink a great deal in seasoning and is best avoided as a wood for sculptural use, since there is an ever-present danger with this wood of subsequent physical changes such as swelling or shrinking and warping with changes of atmospheric humidity.

121

Sequoia, see *Redwood.*
Silk Cotton Tree, see *Ceiba.*
Silky Oak, see *Lacewood.*
Silver Maple, see *Maple.*
Sinora, see *Sonora.*
Sipo, see *Sapele.*
Sisso (*Dalbergia sissoo*, Roxb.) is a hard, strong and very durable wood
 which is imported from India. It has a warm brown color and is
 occasionally streaked with darker brown. The wood is very rare in
 the United States and is generally expensive.
Slippery Elm, see *Elm.*
Smoke Tree, see *Chittam.*
Snakewood (*Piratinera guianensis*) is also referred to as *Leopardwood* and
 Letterwood. It is a tropical hardwood which is imported from
 the Dutch East Indies and British Guiana. The wood is hard to
 carve and has a tendency to split, but is generally durable. It has
 a warm reddish-brown color with dark spots that occasionally
 resemble leopard or reptilian markings. The wood has a bitter
 taste and is believed by the natives of the regions in which it
 grows to be a specific remedy for the bite of the venomous
 hooded cobra. Snakewood takes a fine polish and is quite
 frequently available in small logs with a maximum diameter of
 about 8 inches. The wood weighs about 80 pounds per cubic foot.
Sneezewood is a South African wood with a yellowish color which deepens
 to a dark brown toward the center. Fine dust particles of this
 wood frequently irritate the nasal membranes and cause sneezing.
Soft Elm, see *Elm.*
Soft Maple, see *Maple.*
Soft Pine, see *Pine.*
Solera, see *Canaletta.*
Sonora (*Shorea philippinensis*) is a hardwood from the Philippine Islands
 which is also known as *Manggasinora,* and *Sinora.* It is a pale
 yellow to delicate brown, fine-textured wood, which is also rather
 heavy. The wood is generally available and is moderately priced.
Sour Gum, see *Gum, Black.*
South American Grenadilla, see *Ebony.*
South American "Mahogany", see *Beefwood.*
Southern Gum, see *Gumwood.*

Southern Oak, see *Oak.*

Southern Red Cedar, see *Cedar.*

Southern Red Gum, see *Gumwood.*

Spanish Cedar, see *Cedar.*

Spanish Mahogany, see *Mahogany.*

Spanish Walnut, see *Cativo.*

Spruce is a soft wood which carves easily and is suitable for small pieces.

Sucupira (Bowdichia spp.) is a South American hardwood which grows in Brazil and Venezuela. It is also called *Acapa, Acapu,* and *Amoteak.* The heartwood is an intense chocolate brown color with lighter brown stripes. Sucupira is hard and heavy and has a fairly coarse texture. The wood is quite rare in the United States.

Sugarberry, see *Hackberry.*

Sugar Maple, see *Maple.*

Sugar Pine, see *Pine.*

Sweet Beech, see *Beech.*

Sweet Gum, see *Gumwood.*

Sycamore is a term which is used to describe several unrelated species.

American Sycamore (Platanus occidentalis, Linn.) is also known as *Buttonwood* and *Plane Tree,* and is one of the plane trees. It is a common and native tree in the eastern portion of North America, growing from Maine to the Gulf of Mexico. It is a delicate reddish brown hardwood which is generally available commercially and is inexpensive. American Sycamore permits a delicacy of detail but is fairly difficult to work. It is also quite difficult to season because of the great deal of shrinkage in drying and the accompanying tendency to warp as it dries.

The *California plane tree (Platanus racemosa)* is also called *Buttonball, California plane,* and *Sycamore.* It is native to the western part of North America. The wood is a rather brittle variety, which is also difficult to season.

English Harewood (Acer pseudoplatanus, Linn.) is actually a member of the maple family. It is also known as *English Sycamore,* and *English Whitewood.* It is a light-colored, fine-grained, figured wood, generally available in the form of thin planks. The wood has an unfortunate tendency to warp and crack in seasoning and also tends to rot on outdoor exposure. Sycamore was a popular wood in ancient Egypt.

123

Tabasara, see *Cativo.*

Taito, see *Cativo.*

Tamo, see *Ash, Japanese.*

Tasmanian "Oak", see *Eucalyptus.*

Teak (Tectona grandis) is physically suggestive of oak, but it is lighter and more uniform. Its color varies from a yellow to a dark golden-brown. Teakwood is quite hard, shrinks very little in seasoning, and possesses great physical strength. The wood has a good, even graining which is similar to that of walnut, but it has a porous texture. Teak carves nicely and is quite durable, possessing an oily component which repels insect pests. There are two important varieties: *Asiatic* or *Indian teakwood,* and *African teakwood.* Indian teakwood is the kind generally referred to when teak is mentioned. It weighs about 45 pounds per cubic foot. Asiatic teakwood includes teak from Burma, Ceylon, India, Java, Siam, and Vietnam. The Burmese or Siamese teakwoods are fairly soft and of a medium consistency. They are very durable woods with low shrinkage and swelling factors. Burmese teak carves easily, but rapidly dulls one's chisels. Teakwood is generally available in blocks, logs, and planks. After it has been carved, the wood has a tendency to darken slightly to a chocolate brown color. It can be oiled or waxed. Teakwood is readily available commercially.

Tennessee Red Cedar, see *Cedar.*

Tiama, see *Sapele.*

Tigerwood (Lovoa trichilioides, Lovoa klaineana) is also called *African "Walnut", Benin "Walnut", Congowood,* and *Nigerian Golden "Walnut".* This West African tropical hardwood, however, is not a member of the walnut family. It has been misnamed because of its color. Tigerwood heartwood is a golden brown with black streaks or stripes. It generally has a fine, straight grain which occasionally is beautifully figured. It is usually free of defects, is easily carved, and takes a fine finish without polish. Logs with a decidedly figured graining may, however, present carving problems. Tigerwood weighs about 35 pounds per cubic foot. It is usually available in the form of logs up to three feet in diameter and is moderately priced.

Timbi, see *Edinam.*

124

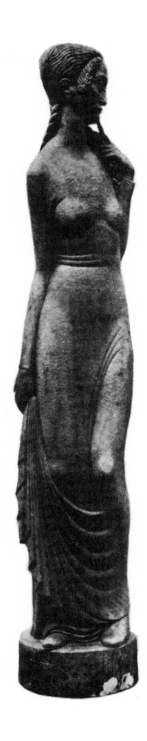

"LA PUCELLE" or *Vestal Virgin*. Lifesize. One of Rosandic's finest carvings in walnut. Rosandic worked almost exclusively in wood.

Private Collection

Tolabranca, see *Agba.*

Tulip Tree Wood, see *Poplar.*

Tulipwood (Dalbergia frutescens var. tormentosa) is a fine-textured, light colored, strong Brazilian hardwood, which is also called *Bois de Rose* and *Brazilian Pinkwood.* Tulipwood is streaked with yellow and reddish-violet stripes. The wood is large pored and is rather difficult to carve because it has a tendency to splinter in working. Tulipwood weighs between 60 and 70 pounds per cubic foot and is fairly expensive. It is generally available in small log form. The wood takes a high polish, but the color tends to fade as time passes.

Tupele, Gum, see *Gum, Tupelo.*

Tupelo, see *Gum, Tupelo.*

Tupelo Gum, see *Gum, Black.*

Turkish Boxwood, see *Boxwood.*

Vermilion Wood, see *Padouk, Andaman,* and *Padouk, Burma.*

Violetwood, see *Amaranth,* also *Kingwood.*

Walnut is one of the finest of the sculptural hardwoods, requiring the use of very sharp tools and wood carving mallets. All of the walnut varieties are very hard and have fine, but tough grains, which permit a delicacy of detail not possible with coarser woods.

American Walnut (Juglans nigra, Linn.) is also called *Black Walnut.* It grows in the United States and southern Canada and is an excellent hard wood for carving purposes. It has a fine texture and beautifully fine and open graining, with a straight to slightly curly figuring. It also has uniformity of mass, is extremely durable even when used under conditions favoring decay, and takes a high polish. The color varies from a light to medium to a dark violet or chocolate brown. American walnut is more open-grained than basswood and should be carved carefully. The wood weighs between 28 and 49 pounds per cubic foot and is generally abundant in logs up to a foot or more in diameter.

Italian Walnut (Juglans regia, Linn.) is a species which is grown in many European countries and is marketed as *Austrian Walnut,* Bulgarian, English, French, Italian, Russian, Spanish, Turkish, etc., according to its source. It is a hard, close-textured and beautiful wood, ideally suitable for delicate and detailed wood carving. This species, particularly the *French Walnut* , is lighter

126

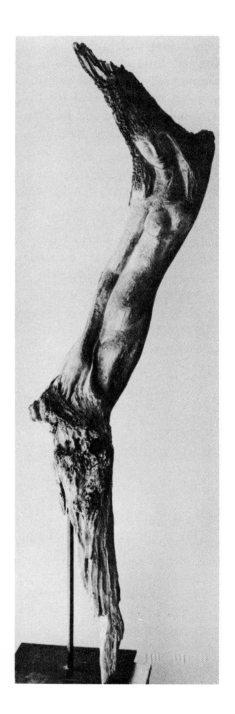

ADELINA, by Lorrie Goulet.
Wild cherry wood. 60 inches high.
Collection of Maximillian Hoffman

127

in color than American walnut, being a grayish brown. Linseed oil darkens walnut, but wax has little effect upon it. Occasionally oxalic acid is used commercially to bleach walnut to a lighter tone, but this practice is not recommended for the sculptor, particularly since natural walnut has a really beautiful color. A raw and untreated walnut carving has a very pleasant and attractive appearance.

Water Elm, see *Elm*.

Water Tupelo, see *Gum, Tupelo*.

Wawa, see *Ayous*.

Wenge (Milletia laurentii) is a hard and heavy tropical wood from the Belgian Congo. It is also called *Dikela*. The heartwood of this attractive wood is very dark brown with fine, almost parallel near-black veining. The wood is generally scarce and expensive.

Western Oak, see *Oak*.

West Indian Boxwood, see *Boxwood*.

West Indian Satinwood, see *Satinwood*.

White Birch, see *Birch*.

White Cedar, see *Cedar*.

White Elm, see *Elm*.

"White Mahogany", see *Primavera*.

White Oak, see *Oak*.

White Walnut, see *Butternut*.

Whitewood, see *Poplar*.

Wild Black Cherry, see *Cherry*.

Wild Cherry, see *Cherry*.

Wild Dilly, see *Beefwood*.

Willow (Salix) has many species. The wood has a straight grain and a white color which tends to darken on exposure to the atmosphere to a pale brown. Willow is fairly light in weight and also quite soft, but tough.

Yellow Birch, see *Birch*.

Yellow Locust, see *Locust*.

Yellow Poplar, see *Poplar*.

Yew is a hard and very fine-grained wood. The *American Yew* variety *(Taxus brevifolia)* is a reddish-brown wood which is secured from the Pacific coast states and the Canadian southwest. It is a hard and heavy wood which is difficult to secure in large sizes and is

also rather expensive. The wood has been used extensively for archery bows and also employed for wood carving, although the wood is difficult to carve. The *English Yew* (*Taxus baccata,* Linn.) is a paler red to brownish-color variety with a smooth grain. It, also, is hard and strong and costly to acquire.

Zapatero, see *Boxwood,* West Indian.

Zebrawood (Microberlinia brazzavillanensis) is also called *Zebrano* and *Zingana*. It is a light colored tropical hardwood imported from west African countries, notably African Cameroon and Gaboon. The name of the wood is derived from its fine but pronounced, dark brown, striped graining. It is generally available in the form of very large logs. The wood exudes an odor when it is carved. Zebrawood is a hard and heavy wood with a fairly coarse texture. While it is generally available, it is expensive.

Zebrano, see *Zebrawood.*

Zingana, see *Zebrawood.*

Ziricote, see *Canaletta.*

WORKING QUALITIES OF WOOD

The ease with which wood can be worked or carved with hand tools varies considerably, but no test has yet been devised to classify *scientifically* varieties of wood according to their workability. The following tables have been developed from several sources.*

Ease of Working with Hand Tools

SOFTWOODS (Coniferous)

Easy to work	Medium-hard to work	Hard to work
Balsa	Cedar, Eastern red	Douglas fir
Cedar	Cypress, Southern	Larch, Western
Pine	Fir	Pine, Southern yellow
	Hemlock	Yew
	Pine, lodgepole	
	Redwood	
	Spruce	

* The most important of these sources was the *Wood Handbook,* an unnumbered publication of the U.S. Dept. of Agriculture, Washington, D. C.

HARDWOODS (Deciduous)

Easy to work	Medium-to-hard to work
Alder, red	Ash, commercial white
Aspen	Beech
Basswood	Birch (types vary)
Buckeye	Cherry
Soft maple	Chinquapin, Western
Willow	Cocobolo
Yellow poplar	Cottonwood
	Ebony
	Elm
	Gumwood
	Hickory
	Honey locust
	Lignum vitae (very hard)
	Locust, black (very hard)
	Magnolia
	Mahogany (both easy- and hard-to-work types)
	Maple, hard
	Oak
	Primavera
	Rosewood
	Snakewood
	Sycamore
	Teakwood (some varieties easy to medium-hard to work)
	Walnut

TOXICITY OF WOOD

Most wood carvers are quite unaware of the potential health hazards of physical exposure to some varieties of wood. While it is theoretically true that any wood variety may cause an allergic reaction in a sensitized individual, exposure to some species of wood, including members of the beech, birch, mahogany, myrtle, and pine families, and some of the tropical wood varieties, are known to have caused allergic reactions in normal individuals.

I use the word "toxic" to mean poisonous. "Irritant" or "allergenic" pertain to substances capable of causing localized cutaneous and/or respiratory reactions. Some wood varieties, such as East Indian satinwood and South American boxwood, are definitely known to be toxic. Others, such as cocobolo, are primarily irritants. However, it is also very true that individuals vary markedly in their reaction to potentially allergenic materials and to actual toxins, and that many people are rarely or only slightly affected.

It is important, therefore, in carving or other exposure to any new wood variety, that one should consciously be on the alert for physical reactions such as localized skin irritations, itching, or sneezing.

In the event that the skin of the fingers becomes irritated or begins to itch while a wood mass is being worked, it is advisable to stop working and to wash the hands thoroughly with a bland soap.

Rubber surgical gloves or the new commercially available thin, polyethylene gloves may be worn to protect the hands while carving wood which has previously caused cutaneous irritation or a localized dermatitis.

132

These gloves are very thin and will not hamper finger or hand movement. The hands and gloves should be powdered well before putting on the gloves, to both lubricate the gloves and to minimize the effects of perspiration while wearing the gloves, since moisture will be retained inside the gloves while they are being worn.

A protective filter-type face mask can be used to prevent breathing in fine, potentially irritating wood dust particles.

Wood Variety	Possible Physical Effects
Cashew wood	irritating to the skin
Cocobolo	irritating to the skin
Epplewood	nasal congestion, symptoms of hay fever
Greenheart	wood splinters may prove toxic
Rosewood, Brazilian	irritating to the skin, skin rashes
Satinwood, East Indian	toxic
South American Boxwood	irritating to the skin, toxic

WEIGHT

The weight of a variety of wood may be used as a rough means of determining the relative hardness of the wood, since it is generally true that the hardness and strength of a species of wood is proportional to its weight. The heavier varieties being harder and stronger than the lighter weight woods.

Lighter weight woods weighing up to about 25 pounds per cubic foot may be considered softwoods. Those ranging in weight from about 25 pounds to 55 or 60 pounds per cubic foot are classified as medium to hard. Woods weighing above 60 pounds per cubic foot are considered very hard varieties.

The weight of wood varies considerably with moisture content. Green or fresh wood possesses the largest quantity of moisture and is, naturally, substantially heavier than normal, air-dried wood. Artificially dried or heat-dried wood is lightest in weight. The approximate weights of some varieties of wood in terms of pounds per cubic foot, in a normal air-dried condition (without artificial heating), is as follows:

	Pounds per Cubic Foot		Pounds per Cubic Foot
Afrormosia	45	Lignum Vitae	85
Agba	32	Locust	45
Amaranth	62	Magnolia	29
Apple, European	48	Mahogany, African	31-35
Ash	45	West Indian	25
Aspen	26	Makore	40
Avodire	25	Mansonia	37
Ayous	25	Maple (average)	39-49
Balsa	5-10	Oak (average)	45
Banak	28	Okoume	25
Basswood	26	Padouk	43-57
Beech	43	Pearwood, European	43
Beefwood	55-61	Pecan	48
Birch (average)	41	Peroba, Red	45
Boxwood	45	Persimmon	59
Butternut	26	Pine	25-47
Cherry, Black	35	Plumwood	35-50
Chestnut	30	Primavera, "white mahogany"	30-37
Cocobola	60-75	Quebracho	70-80
Dogwood	50	Redwood	26
Ebony, African Gaboon	78	Rosewood	48-70
Brown	80	Sabicu	55
Macassar	70	Sandalwood	60
Mozambique	54	Sapele	35-40
Elm	35	Sassafras	31
Epplewood	60	Satinwood	50-68
Eucalyptus	43-69	Snakewood	70-84
Greenheart	65-75	Sycamore	33
Gum, Black	39	Teakwood	45
Gum, Tupelo	32	Tigerwood	35
Hickory, true	40-52	Tulipwood	60-70
Imbuya	40-45	Walnut	28-49
Ivorywood	45-52	Zebrawood	48-65
Kingwood	75		

135

SEASONING

When a tree is cut, between 20 and 50 per cent of the weight of the wood is water. This water content varies markedly in different species of wood. The wood mass begins to lose this moisture immediately after being cut, and the loss continues until the moisture content may decrease to a level as low as 4 or 5 per cent.

A well-seasoned wood is best for carving. This fact cannot be emphasized too strongly: *never carve an unseasoned wood.* The use of so-called "green wood", or a wood not properly seasoned, may result in irreparable damage to a finished carving. Shrinkage and possible cracking may occur during carving as the wood dries or matures, and a finished carving in an unseasoned wood may be eventually ruined by the development of cracks and splits.

Some sculptors make a practice of purchasing wood in logs or blocks and setting these aside in a protected bin or other part of the studio, preferably raised clear of the floor, to age or dry slowly in a uniform environment away from heat or sunlight and amid a good circulation of air. This is an excellent practice and one to be heartily recommended, particularly with large logs. One should first strip off the bark and then apply several coats of shellac to both ends of the log or block to minimize the possibility of the cracking or splitting to which these areas are prone.

If a tree is to be cut for carving wood, plan to do the cutting in the winter,

when the sap is down. Some sculptors advocate the practice of drilling tiny holes at right angles to the core to permit internal drying. While this procedure may minimize checking of the wood mass, it may mar the surface of the finished carving. A more practical means of reducing the possibility of checking is to drill a hole through the center of the log with an auger. The resulting hole will give the wood mass more internal room to contract, in drying.

Seasoning reduces the weight of the wood by reducing the moisture content of the mass. It serves also to increase the physical strength of the wood and to prevent undue ˙checking or splitting, decay, and volume changes after carving. (Checks, the deep cracks in a wood block or splits along the vascular rays, result from uncontrolled drying or seasoning.) As a wood mass dries, the moisture or "cell water" in the microscopic cells slowly evaporates and a contraction or shrinkage takes place, with the greatest stress or movement across the graining. The movement with the grain is generally small. External vertical checking is due to shrinkage around the heartwood or center of the log. There are many tropical varieties which check very little because of the compactness of grain.

Warping is an undesirable bending or twisting of a wood mass.

The rate of drying of wood depends upon the variety of the wood, the size and shape of the wood mass, and upon the drying method employed. Very hard woods such as ebony and lignum vitae require more time for seasoning than do softer woods such as mahogany and walnut.

There are two important methods of drying or seasoning wood: (1) natural seasoning or air-drying, and (2) kiln-drying or hot-air seasoning.

The natural drying of wood is commonly practiced commercially. The wood is exposed to air outdoors, but is protected from direct sunlight and rain or snow. Fine air-drying may require long periods of time, varying from about 18 months to as long as 5 or 6 years. The period of time required will also vary according to the size or dimensions of the logs. The quick, uncontrolled and uneven drying of wood invariably results in a warping and checking, so that the longer the period of air-drying is, the better will be the results. The maximum moisture retention of wood after air-drying is approximately 10 to 20 per cent.

Kiln-drying or hot-air seasoning is the more economical method in terms of time and is also utilized commercially. It is a more complete means of ridding wood masses of excess moisture, as the process generally results in a wood that has a maximum moisture retention of about 5 per cent when

it leaves the kiln. However, after its removal from the kiln, the wood has a tendency to reabsorb moisture from the air.

Small blocks of wood are occasionally seasoned by being boiled in water and then permitted to dry. This procedure apparently dissolves albuminous matter and permits the freer evaporation of the moisture contained in the wood, but it appears to be a dangerous procedure because it may weaken the physical structure of the wood.

Hardwoods are quite frequently air-dried for several months before they are kiln-dried.

Oak is an extremely difficult wood to dry or to season satisfactorily. When oak and other varieties of hardwood are dried quickly, with insufficient surrounding moisture, the outer portion of the block dries or "case-hardens" and shrinks before the internal mass. The outer shell frequently checks in shrinking and the inner mass often develops checks or "honeycombs".

WOOD SHRINKAGE

Expansion and shrinkage will be found to vary markedly with different woods. As a general rule, the resinous, light woods will tend to swell or to shrink less than the heavy, non-resinous varieties. Softwoods, therefore, will tend to change less in terms of weight and form than the hardwoods.

Shrinkage should be figured in three ways:

1. Actual volume shrinkage
2. Radial shrinkage or shrinkage between the bark and the center of the log
3. Tangential shrinkage or shrinkage in the direction of circumference.

The radial shrinkage of a wood is invariably less than the tangential shrinkage. The ratio between the two is a determining factor in the resistance of the wood variety to physical warping and twisting. In the table below, the highest figures in the fourth column indicate the highest relative stability.

Wood Shrinkage Factors

HARDWOODS	Percentage of shrinkage in volume	Percentage of radial shrinkage or shrinkage between bark and center of log	Percentage of tangential shrinkage or shrinkage in the direction of circumference	Ratio of radial to tangential shrinkage
Mahogany, Cuban	6.0	2.7	3.3	81.8
Mahogany, Central American	7.7	3.5	4.8	73.0
Mahogany, African	8.8	4.1	5.8	71.0
Walnut	11.3	5.2	7.1	73.2
Yellow Poplar	11.4	4.1	6.9	62.7
Cherry	11.5	3.7	7.1	52.1
Maple, Silver	12.0	3.0	7.2	41.6
Ash, White	12.6	4.3	6.4	67.2
Willow	13.3	2.2	8.2	27.0
Maple, Sugar	14.4	4.9	9.1	53.8
Elm, American	14.4	4.2	9.5	44.2
Gum, Red	15.0	5.2	9.9	52.5
White Oak	16.0	4.8	9.2	52.2
Hickory, Shagbark	16.0	6.5	10.2	63.7
Pecan	16.0	4.9	8.9	53.9
Southern Red Oak	16.3	4.5	8.7	51.7
Beech	16.5	4.6	10.5	42.8
Birch, Yellow	17.0	7.9	9.0	88.0

Courtesy of the Mahogany Association, Inc.

BIBLIOGRAPHY

For varieties see:

Howard, Alexander L., *Manual of the Timbers of the World: Their Characteristics and Uses:* revised edition to which is appended an index of vernacular names. Toronto, 1934.

Muenscher, W. C., *Poisonous Plants of the United States,* Macmillan, New York, 1944.

Nomenclature Générale des Bois Tropicaux, 1965. L'Association Technique Internationale des Bois Tropicaux. Nogent-Sur Marne, France.

Pearson, Ralph S. and H. P. Brown, *Commercial Timbers of India: Their Distribution, Supplies, Anatomical Structure, Physical and Mechanical Properties and Uses.* Bombay, 1932.

Record, S. J., and R. W. Hess, *Timbers of the New World,* New Haven, 1943.

Reyes, Luis J., *Philippine Woods* (Technical bul. No. 7), Bur. of Science, 1938.

Snow, C. H., *The Principal Species of Wood,* New York, 1910.

Stone, Herbert, *Textbook of Wood,* New York, 1921.

Stone, Herbert, *Timbers of Commerce and Their Identification,* New York, 1918.

Wood Handbook, an unnumbered publication of the U.S. Department of Agriculture, Washington, D.C.

For wood carving see:

Durst, Alan, *Wood Carving,* Studio, Ltd., 1928.

Maskell, A., *Wood Sculpture,* London, 1911.

For structure see:

Williams, Simon, *Wood Structure,* Scientific American, January, 1953. Vol. 188, No. 1, p. 64-67.

For contemporary sculptors who have used wood extensively see:

Ernst Barlach, Deutsche Akademie Der Künste, Berlin, 1951.
Constantin Brancusi, by Carola Giedion-Welcker, London and New York, 1959.
José de Creeft, by Jules Campos, New York, 1945.
Chaim Gross, by J. V. Lombardo, New York, 1949.
Barbara Hepworth, by Herbert Read, London, 1952.
Aristide Maillol, by John Rewald, Hyperion, London, Paris, New York, 1939.
Ewald Mataré, by Hanns Theodor Flemming, im Prestel-Verlag, Munich, 1955.
Der Plastiker Mataré, by Ernst Kállai. *Das Kunstblatt,* 11:67-68 ill, 1927.
The Sculpture of Ivan Meštrović, Syracuse University Press, 1948.
Henry Moore, by James Johnson Sweeney, Museum of Modern Art, New York, 1946.
Henry Moore, by Herbert Read, Curt Valentin, New York, 1949.
Henry Moore, A Study of His Life and Work, by Herbert Read, London, 1965, New York, 1966.
Henry Moore on Sculpture, edited by Philip James, London and New York, 1967.
The Sculpture of Picasso, by Roland Penrose, The Museum of Modern Art, New York, 1967.

General references for further reading:

Primitive Art, by Paul S. Wingert, London and New York, 1962.
The Sculpture of Primitive Man, by Warner Muensterberger, Abrams, New York, 1955.
African Negro Art, by James Johnson Sweeney, Museum of Modern Art, New York, 1955.
The Sculpture of Africa, by Eliot Elisofon and William B. Fagg, London and New York, 1958.
Origins of Modern Sculpture, by W. R. Valentiner, Wittenborn, New York, 1946.
Problems of Form, by Adolf Hildebrand, G. E. Stechert and Co., New York, 1907.
The Meaning of Modern Sculpture, by R. H. Wilenski. F. A. Stokes Co., New York, 1935.
Sculpture, by Agnes M. Rindge. Harcourt, Brace and Company, New York, 1929.
The Materials and Methods of Sculpture, by Jack C. Rich. Dover Publications, Inc., New York, 1988.

142

GLOSSARY

Adze An ax-like tool with the cutting blade set at right angles to the handle and curved inwardly toward the handle. It is used for the preliminary roughing out of a wood carving.

Air-drying The process of removing moisture or naturally seasoning fresh or green woods by exposure to the air, without artificial heat, usually in a studio or other protected environment.

Bark The outer layer or protective covering of a tree.

Cambium The growing cells or part of the tree which is just under the bark. Increases in the diameter or growth of trees are the result of these cells which produce internal layers of wood and external bark.

Carving The act of cutting a solid material, such as wood, into form with instruments, such as chisels and/or gouges. The term is also used to describe a finished work so fashioned.

Checking A cracking or separation of the wood mass, generally extending across the annual growth rings, and resulting from the strong physical stresses of drying or seasoning.

Chisel A metallic cutting instrument generally fashioned of steel, one end of which serves as the cutting end while the other receives the motivating pressure or blow. The act of carving with or using a chisel.

Close-grained wood A wood with narrow, virtually inconspicuous annual rings. The term is occasionally used loosely to describe a fine-textured wood or one with closely spaced and small pores.

Coarse-grained wood A wood with wide and prominent annual rings. The term is occasionally used loosely to describe large-pored woods such as ash, chestnut, and oak.

Direct carving A method of carving in which the approach is direct and without recourse to preliminary three-dimensional models.

Figure The natural wood surface pattern resulting from annual growth rings and irregular coloration.

File An abrading tool fashioned of metal.

Gouge A kind of chisel with a curved cutting edge.

Grain Refers to the direction of the wood cells or fibers.

Greenwood Freshly cut wood or wood which has not been seasoned.

Hardwood A botanical classification which embraces broad-leaved, flower-bearing trees. The term does not refer to the actual physical hardness of the wood variety.

Heartwood The internal portion of a tree or log extending from the core, center, or pith to the sapwood. This portion is generally darker in color than the sapwood.

Indirect carving A method of carving in which the approach generally involves the use of a previously prepared three-dimensional model as a guide.

Kiln A heated chamber or oven for drying greenwood.

Kiln-dried Artificially seasoned or oven-dried wood.

Rasp A metallic abrasive tool with sharp, pyramidal teeth.

Relief A form of sculpture in which figures or forms project from a background to which they adhere.

Sapwood The living portion of a tree, between the bark and the heartwood. This portion is generally lighter in color than the heartwood and is more susceptible to decay.

Sculpture-in-the-round Free-standing, three-dimensional forms.

Seasoning The process of reducing the moisture content of green wood in order to increase its durability.

Shrinkage In the process of drying or seasoning a wood mass, a shrinkage results as the mass loses moisture. The shrinkage in a given piece of wood varies markedly in different areas or directions and the resulting stresses may cause cracks or checking.

Slips Specially shaped abrasive stones for sharpening wood carving tools.

Softwood A botanical classification which includes the conifers or trees bearing needle-like leaves. The term does not refer to the actual physical hardness of the wood variety.

Stain Wood discoloration caused by varied agencies, such as chemicals and fungi. The term is also used to describe materials used to color wood.

Taille directe Same as *direct carving.*

Technique The method of performance or treatment. The skills, methods and tools used by the sculptor.

Veneer Thin slices or sheets of wood which generally are from 1/100 to 1/4 of an inch thick.

Wood preservative A substance which, for a variable period of time, will tend to minimize or prevent the action of destructive fungi and/or insects such as wood-borers.

144

INDEX

146

147

148

149

151

154

A CATALOG OF SELECTED

DOVER BOOKS

IN ALL FIELDS OF INTEREST

A CATALOG OF SELECTED
DOVER BOOKS
IN ALL FIELDS OF INTEREST

DRAWINGS OF REMBRANDT, edited by Seymour Slive. Updated Lippmann, Hofstede de Groot edition, with definitive scholarly apparatus. All portraits, biblical sketches, landscapes, nudes. Oriental figures, classical studies, together with selection of work by followers. 550 illustrations. Total of 630pp. 9⅛ × 12¼.
21485-0, 21486-9 Pa., Two-vol. set $29.90

GHOST AND HORROR STORIES OF AMBROSE BIERCE, Ambrose Bierce. 24 tales vividly imagined, strangely prophetic, and decades ahead of their time in technical skill: "The Damned Thing," "An Inhabitant of Carcosa," "The Eyes of the Panther," "Moxon's Master," and 20 more. 199pp. 5⅜ × 8½. 20767-6 Pa. $4.95

ETHICAL WRITINGS OF MAIMONIDES, Maimonides. Most significant ethical works of great medieval sage, newly translated for utmost precision, readability. Laws Concerning Character Traits, Eight Chapters, more. 192pp. 5⅜ × 8½.
24522-5 Pa. $5.95

THE EXPLORATION OF THE COLORADO RIVER AND ITS CANYONS, J. W. Powell. Full text of Powell's 1,000-mile expedition down the fabled Colorado in 1869. Superb account of terrain, geology, vegetation, Indians, famine, mutiny, treacherous rapids, mighty canyons, during exploration of last unknown part of continental U.S. 400pp. 5⅜ × 8½. 20094-9 Pa. $8.95

HISTORY OF PHILOSOPHY, Julián Marías. Clearest one-volume history on the market. Every major philosopher and dozens of others, to Existentialism and later. 505pp. 5⅜ × 8½. 21739-6 Pa. $9.95

ALL ABOUT LIGHTNING, Martin A. Uman. Highly readable nontechnical survey of nature and causes of lightning, thunderstorms, ball lightning, St. Elmo's Fire, much more. Illustrated. 192pp. 5⅜ × 8½. 25237-X Pa. $5.95

SAILING ALONE AROUND THE WORLD, Captain Joshua Slocum. First man to sail around the world, alone, in small boat. One of great feats of seamanship told in delightful manner. 67 illustrations. 294pp. 5⅜ × 8½. 20326-3 Pa. $4.95

LETTERS AND NOTES ON THE MANNERS, CUSTOMS AND CONDI-TIONS OF THE NORTH AMERICAN INDIANS, George Catlin. Classic account of life among Plains Indians: ceremonies, hunt, warfare, etc. 312 plates. 572pp. of text. 6⅛ × 9¼. 22118-0, 22119-9, Pa., Two-vol. set $17.90

THE SECRET LIFE OF SALVADOR DALÍ, Salvador Dalí. Outrageous but fascinating autobiography through Dalí's thirties with scores of drawings and sketches and 80 photographs. A must for lovers of 20th-century art. 432pp. 6½ × 9¼. (Available in U.S. only) 27454-3 Pa. $9.95

THE BOOK OF BEASTS: Being a Translation from a Latin Bestiary of the Twelfth Century, T. H. White. Wonderful catalog of real and fanciful beasts: manticore, griffin, phoenix, amphivius, jaculus, many more. White's witty erudite commentary on scientific, historical aspects enhances fascinating glimpse of medieval mind. Illustrated. 296pp. 5⅜ × 8¼. (Available in U.S. only) 24609-4 Pa. $7.95

FRANK LLOYD WRIGHT: Architecture and Nature with 160 Illustrations, Donald Hoffmann. Profusely illustrated study of influence of nature—especially prairie—on Wright's designs for Fallingwater, Robie House, Guggenheim Museum, other masterpieces. 96pp. 9¼ × 10¾. 25098-9 Pa. $8.95

LIMBERT ARTS AND CRAFTS FURNITURE: The Complete 1903 Catalog, Charles P. Limbert and Company. Rare catalog depicting 188 pieces of Mission-style furniture: fold-down tables and desks, bookcases, library and octagonal tables, chairs, more. Descriptive captions. 80pp. 9⅜ × 12¼. 27120-X Pa. $6.95

YEARS WITH FRANK LLOYD WRIGHT: Apprentice to Genius, Edgar Tafel. Insightful memoir by a former apprentice presents a revealing portrait of Wright the man, the inspired teacher, the greatest American architect. 372 black-and-white illustrations. Preface. Index. vi + 228pp. 8¼ × 11. 24801-1 Pa. $10.95

THE STORY OF KING ARTHUR AND HIS KNIGHTS, Howard Pyle. Enchanting version of King Arthur fable has delighted generations with imaginative narratives of exciting adventures and unforgettable illustrations by the author. 41 illustrations. xviii + 313pp. 6⅛ × 9¼. 21445-1 Pa. $6.95

THE GODS OF THE EGYPTIANS, E. A. Wallis Budge. Thorough coverage of numerous gods of ancient Egypt by foremost Egyptologist. Information on evolution of cults, rites and gods; the cult of Osiris; the Book of the Dead and its rites; the sacred animals and birds; Heaven and Hell; and more. 956pp. 6⅛ × 9¼.
22055-9, 22056-7 Pa., Two-vol. set $22.90

A THEOLOGICO-POLITICAL TREATISE, Benedict Spinoza. Also contains unfinished *Political Treatise*. Great classic on religious liberty, theory of government on common consent. R. Elwes translation. Total of 421pp. 5⅜ × 8½.
20249-6 Pa. $7.95

INCIDENTS OF TRAVEL IN CENTRAL AMERICA, CHIAPAS, AND YUCA-TAN, John L. Stephens. Almost single-handed discovery of Maya culture; exploration of ruined cities, monuments, temples; customs of Indians. 115 drawings. 892pp. 5⅜ × 8½. 22404-X, 22405-8 Pa., Two-vol. set $17.90

LOS CAPRICHOS, Francisco Goya. 80 plates of wild, grotesque monsters and caricatures. Prado manuscript included. 183pp. 6⅜ × 9⅜. 22384-1 Pa. $6.95

AUTOBIOGRAPHY: The Story of My Experiments with Truth, Mohandas K. Gandhi. Not hagiography, but Gandhi in his own words. Boyhood, legal studies, purification, the growth of the Satyagraha (nonviolent protest) movement. Critical, inspiring work of the man who freed India. 480pp. 5⅜ × 8½. (Available in U.S. only)
24593-4 Pa. $6.95

ILLUSTRATED DICTIONARY OF HISTORIC ARCHITECTURE, edited by Cyril M. Harris. Extraordinary compendium of clear, concise definitions for over 5,000 important architectural terms complemented by over 2,000 line drawings. Covers full spectrum of architecture from ancient ruins to 20th-century Modernism. Preface. 592pp. 7½ × 9⅝. 24444-X Pa. $15.95

THE NIGHT BEFORE CHRISTMAS, Clement C. Moore. Full text, and woodcuts from original 1848 book. Also critical, historical material. 19 illustrations. 40pp. 4⅝ × 6. 22797-9 Pa. $2.50

THE LESSON OF JAPANESE ARCHITECTURE: 165 Photographs, Jiro Harada. Memorable gallery of 165 photographs taken in the 1930s of exquisite Japanese homes of the well-to-do and historic buildings. 13 line diagrams. 192pp. 8⅜ × 11¼. 24778-3 Pa. $10.95

THE AUTOBIOGRAPHY OF CHARLES DARWIN AND SELECTED LETTERS, edited by Francis Darwin. The fascinating life of eccentric genius composed of an intimate memoir by Darwin (intended for his children); commentary by his son, Francis; hundreds of fragments from notebooks, journals, papers; and letters to and from Lyell, Hooker, Huxley, Wallace and Henslow. xi + 365pp. 5⅜ × 8. 20479-0 Pa. $6.95

WONDERS OF THE SKY: Observing Rainbows, Comets, Eclipses, the Stars and Other Phenomena, Fred Schaaf. Charming, easy-to-read poetic guide to all manner of celestial events visible to the naked eye. Mock suns, glories, Belt of Venus, more. Illustrated. 299pp. 5¼ × 8¼. 24402-4 Pa. $8.95

BURNHAM'S CELESTIAL HANDBOOK, Robert Burnham, Jr. Thorough guide to the stars beyond our solar system. Exhaustive treatment. Alphabetical by constellation: Andromeda to Cetus in Vol. 1; Chamaeleon to Orion in Vol. 2; and Pavo to Vulpecula in Vol. 3. Hundreds of illustrations. Index in Vol. 3. 2,000pp. 6⅛ × 9¼. 23567-X, 23568-8, 23673-0 Pa., Three-vol. set $41.85

STAR NAMES: Their Lore and Meaning, Richard Hinckley Allen. Fascinating history of names various cultures have given to constellations and literary and folkloristic uses that have been made of stars. Indexes to subjects. Arabic and Greek names. Biblical references. Bibliography. 563pp. 5⅜ × 8½. 21079-0 Pa. $9.95

THIRTY YEARS THAT SHOOK PHYSICS: The Story of Quantum Theory, George Gamow. Lucid, accessible introduction to influential theory of energy and matter. Careful explanations of Dirac's anti-particles, Bohr's model of the atom, much more. 12 plates. Numerous drawings. 240pp. 5⅜ × 8½. 24895-X Pa. $6.95

CHINESE DOMESTIC FURNITURE IN PHOTOGRAPHS AND MEASURED DRAWINGS, Gustav Ecke. A rare volume, now affordably priced for antique collectors, furniture buffs and art historians. Detailed review of styles ranging from early Shang to late Ming. Unabridged republication. 161 black-and-white drawings, photos. Total of 224pp. 8⅞ × 11¼. (Available in U.S. only) 25171-3 Pa. $14.95

VINCENT VAN GOGH: A Biography, Julius Meier-Graefe. Dynamic, penetrating study of artist's life, relationship with brother, Theo, painting techniques, travels, more. Readable, engrossing. 160pp. 5⅜ × 8½. (Available in U.S. only) 25253-1 Pa. $4.95

HOW TO WRITE, Gertrude Stein. Gertrude Stein claimed anyone could understand her unconventional writing—here are clues to help. Fascinating improvisations, language experiments, explanations illuminate Stein's craft and the art of writing. Total of 414pp. 4⅝ × 6⅜. 23144-5 Pa. $6.95

ADVENTURES AT SEA IN THE GREAT AGE OF SAIL: Five Firsthand Narratives, edited by Elliot Snow. Rare true accounts of exploration, whaling, shipwreck, fierce natives, trade, shipboard life, more. 33 illustrations. Introduction. 353pp. 5⅜ × 8½. 25177-2 Pa. $9.95

THE HERBAL OR GENERAL HISTORY OF PLANTS, John Gerard. Classic descriptions of about 2,850 plants—with over 2,700 illustrations—includes Latin and English names, physical descriptions, varieties, time and place of growth, more. 2,706 illustrations. xlv + 1,678pp. 8½ × 12¼. 23147-X Cloth. $89.95

DOROTHY AND THE WIZARD IN OZ, L. Frank Baum. Dorothy and the Wizard visit the center of the Earth, where people are vegetables, glass houses grow and Oz characters reappear. Classic sequel to *Wizard of Oz*. 256pp. 5⅜ × 8.
24714-7 Pa. $5.95

SONGS OF EXPERIENCE: Facsimile Reproduction with 26 Plates in Full Color, William Blake. This facsimile of Blake's original "Illuminated Book" reproduces 26 full-color plates from a rare 1826 edition. Includes "The Tyger," "London," "Holy Thursday," and other immortal poems. 26 color plates. Printed text of poems. 48pp. 5¼ × 7. 24636-1 Pa. $3.95

SONGS OF INNOCENCE, William Blake. The first and most popular of Blake's famous "Illuminated Books," in a facsimile edition reproducing all 31 brightly colored plates. Additional printed text of each poem. 64pp. 5¼ × 7.
22764-2 Pa. $3.95

PRECIOUS STONES, Max Bauer. Classic, thorough study of diamonds, rubies, emeralds, garnets, etc.: physical character, occurrence, properties, use, similar topics. 20 plates, 8 in color. 94 figures. 659pp. 6⅛ × 9¼.
21910-0, 21911-9 Pa., Two-vol. set $21.90

ENCYCLOPEDIA OF VICTORIAN NEEDLEWORK, S. F. A. Caulfeild and Blanche Saward. Full, precise descriptions of stitches, techniques for dozens of needlecrafts—most exhaustive reference of its kind. Over 800 figures. Total of 679pp. 8⅜ × 11. 22800-2, 22801-0 Pa., Two-vol. set $26.90

THE MARVELOUS LAND OF OZ, L. Frank Baum. Second Oz book, the Scarecrow and Tin Woodman are back with hero named Tip, Oz magic. 136 illustrations. 287pp. 5⅜ × 8½. 20692-0 Pa. $5.95

WILD FOWL DECOYS, Joel Barber. Basic book on the subject, by foremost authority and collector. Reveals history of decoy making and rigging, place in American culture, different kinds of decoys, how to make them, and how to use them. 140 plates. 156pp. 7⅞ × 10¾. 20011-6 Pa. $14.95

HISTORY OF LACE, Mrs. Bury Palliser. Definitive, profusely illustrated chronicle of lace from earliest times to late 19th century. Laces of Italy, Greece, England, France, Belgium, etc. Landmark of needlework scholarship. 266 illustrations. 672pp. 6⅛ × 9¼. 24742-2 Pa. $16.95

ILLUSTRATED GUIDE TO SHAKER FURNITURE, Robert Meader. All furniture and appurtenances, with much on unknown local styles. 235 photos. 146pp. 9 × 12. 22819-3 Pa. $9.95

WHALE SHIPS AND WHALING: A Pictorial Survey, George Francis Dow. Over 200 vintage engravings, drawings, photographs of barks, brigs, cutters, other vessels. Also harpoons, lances, whaling guns, many other artifacts. Comprehensive text by foremost authority. 207 black-and-white illustrations. 288pp. 6 × 9. 24808-9 Pa. $9.95

THE BERTRAMS, Anthony Trollope. Powerful portrayal of blind self-will and thwarted ambition includes one of Trollope's most heartrending love stories. 497pp. 5⅜ × 8½. 25119-5 Pa. $9.95

ADVENTURES WITH A HAND LENS, Richard Headstrom. Clearly written guide to observing and studying flowers and grasses, fish scales, moth and insect wings, egg cases, buds, feathers, seeds, leaf scars, moss, molds, ferns, common crystals, etc.—all with an ordinary, inexpensive magnifying glass. 209 exact line drawings aid in your discoveries. 220pp. 5⅜ × 8½. 23330-8 Pa. $5.95

RODIN ON ART AND ARTISTS, Auguste Rodin. Great sculptor's candid, wide-ranging comments on meaning of art; great artists; relation of sculpture to poetry, painting, music; philosophy of life, more. 76 superb black-and-white illustrations of Rodin's sculpture, drawings and prints. 119pp. 8⅜ × 11¼. 24487-3 Pa. $7.95

FIFTY CLASSIC FRENCH FILMS, 1912–1982: A Pictorial Record, Anthony Slide. Memorable stills from Grand Illusion, Beauty and the Beast, Hiroshima, Mon Amour, many more. Credits, plot synopses, reviews, etc. 160pp. 8¼ × 11. 25256-6 Pa. $11.95

THE PRINCIPLES OF PSYCHOLOGY, William James. Famous long course complete, unabridged. Stream of thought, time perception, memory, experimental methods; great work decades ahead of its time. 94 figures. 1,391pp. 5⅜ × 8½. 20381-6, 20382-4 Pa., Two-vol. set $25.90

BODIES IN A BOOKSHOP, R. T. Campbell. Challenging mystery of blackmail and murder with ingenious plot and superbly drawn characters. In the best tradition of British suspense fiction. 192pp. 5⅜ × 8½. 24720-1 Pa. $5.95

CALLAS: Portrait of a Prima Donna, George Jellinek. Renowned commentator on the musical scene chronicles incredible career and life of the most controversial, fascinating, influential operatic personality of our time. 64 black-and-white photographs. 416pp. 5⅜ × 8¼. 25047-4 Pa. $8.95

GEOMETRY, RELATIVITY AND THE FOURTH DIMENSION, Rudolph Rucker. Exposition of fourth dimension, concepts of relativity as Flatland characters continue adventures. Popular, easily followed yet accurate, profound. 141 illustrations. 133pp. 5⅜ × 8½. 23400-2 Pa. $4.95

HOUSEHOLD STORIES BY THE BROTHERS GRIMM, with pictures by Walter Crane. 53 classic stories—Rumpelstiltskin, Rapunzel, Hansel and Gretel, the Fisherman and his Wife, Snow White, Tom Thumb, Sleeping Beauty, Cinderella, and so much more—lavishly illustrated with original 19th-century drawings. 114 illustrations. x + 269pp. 5⅜ × 8½. 21080-4 Pa. $4.95

SUNDIALS, Albert Waugh. Far and away the best, most thorough coverage of ideas, mathematics concerned, types, construction, adjusting anywhere. Over 100 illustrations. 230pp. 5⅜ × 8½. 22947-5 Pa. $5.95

PICTURE HISTORY OF THE NORMANDIE: With 190 Illustrations, Frank O. Braynard. Full story of legendary French ocean liner: Art Deco interiors, design innovations, furnishings, celebrities, maiden voyage, tragic fire, much more. Extensive text. 144pp. 8⅜ × 11¼. 25257-4 Pa. $11.95

THE FIRST AMERICAN COOKBOOK: A Facsimile of "American Cookery," 1796, Amelia Simmons. Facsimile of the first American-written cookbook published in the United States contains authentic recipes for colonial favorites— pumpkin pudding, winter squash pudding, spruce beer, Indian slapjacks, and more. Introductory Essay and Glossary of colonial cooking terms. 80pp. 5⅜ × 8½.
24710-4 Pa. $3.50

101 PUZZLES IN THOUGHT AND LOGIC, C. R. Wylie, Jr. Solve murders and robberies, find out which fishermen are liars, how a blind man could possibly identify a color—purely by your own reasoning! 107pp. 5⅜ × 8½. 20367-0 Pa. $2.95

ANCIENT EGYPTIAN MYTHS AND LEGENDS, Lewis Spence. Examines animism, totemism, fetishism, creation myths, deities, alchemy, art and magic, other topics. Over 50 illustrations. 432pp. 5⅜ × 8½. 26525-0 Pa. $8.95

ANTHROPOLOGY AND MODERN LIFE, Franz Boas. Great anthropologist's classic treatise on race and culture. Introduction by Ruth Bunzel. Only inexpensive paperback edition. 255pp. 5⅜ × 8½. 25245-0 Pa. $7.95

THE TALE OF PETER RABBIT, Beatrix Potter. The inimitable Peter's terrifying adventure in Mr. McGregor's garden, with all 27 wonderful, full-color Potter illustrations. 55pp. 4¼ × 5½. 22827-4 Pa. $1.75

THREE PROPHETIC SCIENCE FICTION NOVELS, H. G. Wells. *When the Sleeper Wakes, A Story of the Days to Come* and *The Time Machine* (full version). 335pp. 5⅜ × 8½. (Available in U.S. only) 20605-X Pa. $8.95

APICIUS COOKERY AND DINING IN IMPERIAL ROME, edited and translated by Joseph Dommers Vehling. Oldest known cookbook in existence offers readers a clear picture of what foods Romans ate, how they prepared them, etc. 49 illustrations. 301pp. 6⅛ × 9¼. 23563-7 Pa. $8.95

SHAKESPEARE LEXICON AND QUOTATION DICTIONARY, Alexander Schmidt. Full definitions, locations, shades of meaning of every word in plays and poems. More than 50,000 exact quotations. 1,485pp. 6½ × 9¼.
22726-X, 22727-8 Pa., Two-vol. set $31.90

THE WORLD'S GREAT SPEECHES, edited by Lewis Copeland and Lawrence W. Lamm. Vast collection of 278 speeches from Greeks to 1970. Powerful and effective models; unique look at history. 842pp. 5⅜ × 8½. 20468-5 Pa. $12.95

THE BLUE FAIRY BOOK, Andrew Lang. The first, most famous collection, with many familiar tales: Little Red Riding Hood, Aladdin and the Wonderful Lamp, Puss in Boots, Sleeping Beauty, Hansel and Gretel, Rumpelstiltskin; 37 in all. 138 illustrations. 390pp. 5⅜ × 8½. 21437-0 Pa. $6.95

THE STORY OF THE CHAMPIONS OF THE ROUND TABLE, Howard Pyle. Sir Launcelot, Sir Tristram and Sir Percival in spirited adventures of love and triumph retold in Pyle's inimitable style. 50 drawings, 31 full-page. xviii + 329pp. 6½ × 9¼. 21883-X Pa. $7.95

THE MYTHS OF THE NORTH AMERICAN INDIANS, Lewis Spence. Myths and legends of the Algonquins, Iroquois, Pawnees and Sioux with comprehensive historical and ethnological commentary. 36 illustrations. 5⅜ × 8½.
25967-6 Pa. $8.95

GREAT DINOSAUR HUNTERS AND THEIR DISCOVERIES, Edwin H. Colbert. Fascinating, lavishly illustrated chronicle of dinosaur research, 1820s to 1960. Achievements of Cope, Marsh, Brown, Buckland, Mantell, Huxley, many others. 384pp. 5¼ × 8¼. 24701-5 Pa. $8.95

THE TASTEMAKERS, Russell Lynes. Informal, illustrated social history of American taste 1850s–1950s. First popularized categories Highbrow, Lowbrow, Middlebrow. 129 illustrations. New (1979) afterword. 384pp. 6 × 9.
23993-4 Pa. $8.95

NORTH AMERICAN INDIAN LIFE: Customs and Traditions of 23 Tribes, Elsie Clews Parsons (ed.). 27 fictionalized essays by noted anthropologists examine religion, customs, government, additional facets of life among the Winnebago, Crow, Zuni, Eskimo, other tribes. 480pp. 6⅛ × 9¼. 27377-6 Pa. $10.95

AUTHENTIC VICTORIAN DECORATION AND ORNAMENTATION IN FULL COLOR: 46 Plates from "Studies in Design," Christopher Dresser. Superb full-color lithographs reproduced from rare original portfolio of a major Victorian designer. 48pp. 9¼ × 12¼. 25083-0 Pa. $7.95

PRIMITIVE ART, Franz Boas. Remains the best text ever prepared on subject, thoroughly discussing Indian, African, Asian, Australian, and, especially, Northern American primitive art. Over 950 illustrations show ceramics, masks, totem poles, weapons, textiles, paintings, much more. 376pp. 5⅜ × 8. 20025-6 Pa. $8.95

SIDELIGHTS ON RELATIVITY, Albert Einstein. Unabridged republication of two lectures delivered by the great physicist in 1920–21. *Ether and Relativity* and *Geometry and Experience*. Elegant ideas in nonmathematical form, accessible to intelligent layman. vi + 56pp. 5⅜ × 8½. 24511-X Pa. $3.95

THE WIT AND HUMOR OF OSCAR WILDE, edited by Alvin Redman. More than 1,000 ripostes, paradoxes, wisecracks: Work is the curse of the drinking classes, I can resist everything except temptation, etc. 258pp. 5⅜ × 8½. 20602-5 Pa. $4.95

ADVENTURES WITH A MICROSCOPE, Richard Headstrom. 59 adventures with clothing fibers, protozoa, ferns and lichens, roots and leaves, much more. 142 illustrations. 232pp. 5⅜ × 8½. 23471-1 Pa. $4.95

PLANTS OF THE BIBLE, Harold N. Moldenke and Alma L. Moldenke. Standard reference to all 230 plants mentioned in Scriptures. Latin name, biblical reference, uses, modern identity, much more. Unsurpassed encyclopedic resource for scholars, botanists, nature lovers, students of Bible. Bibliography. Indexes. 123 black-and-white illustrations. 384pp. 6 × 9. 25069-5 Pa. $9.95

FAMOUS AMERICAN WOMEN: A Biographical Dictionary from Colonial Times to the Present, Robert McHenry, ed. From Pocahontas to Rosa Parks, 1,035 distinguished American women documented in separate biographical entries. Accurate, up-to-date data, numerous categories, spans 400 years. Indices. 493pp. 6½ × 9¼. 24523-3 Pa. $11.95

THE FABULOUS INTERIORS OF THE GREAT OCEAN LINERS IN HISTORIC PHOTOGRAPHS, William H. Miller, Jr. Some 200 superb photographs capture exquisite interiors of world's great "floating palaces"—1890s to 1980s: *Titanic, Ile de France, Queen Elizabeth, United States, Europa,* more. Approx. 200 black-and-white photographs. Captions. Text. Introduction. 160pp. 8⅜ × 11¾. 24756-2 Pa. $10.95

THE GREAT LUXURY LINERS, 1927–1954: A Photographic Record, William H. Miller, Jr. Nostalgic tribute to heyday of ocean liners. 186 photos of *Ile de France, Normandie, Leviathan, Queen Elizabeth, United States,* many others. Interior and exterior views. Introduction. Captions. 160pp. 9 × 12. 24056-8 Pa. $12.95

A NATURAL HISTORY OF THE DUCKS, John Charles Phillips. Great landmark of ornithology offers complete detailed coverage of nearly 200 species and subspecies of ducks: gadwall, sheldrake, merganser, pintail, many more. 74 full-color plates, 102 black-and-white. Bibliography. Total of 1,920pp. 8⅜ × 11¼. 25141-1, 25142-X Cloth., Two-vol. set $100.00

THE COMPLETE "MASTERS OF THE POSTER": All 256 Color Plates from "Les Maîtres de l'Affiche", Stanley Appelbaum (ed.). The most famous compilation ever made of the art of the great age of the poster, featuring works by Chéret, Steinlen, Toulouse-Lautrec, nearly 100 other artists. One poster per page. 272pp. 9¼ × 12¼. 26309-6 Pa. $29.95

THE TEN BOOKS OF ARCHITECTURE: The 1755 Leoni Edition, Leon Battista Alberti. Rare classic helped introduce the glories of ancient architecture to the Renaissance. 68 black-and-white plates. 336pp. 8⅜ × 11¼. 25239-6 Pa. $14.95

MISS MACKENZIE, Anthony Trollope. Minor masterpieces by Victorian master unmasks many truths about life in 19th-century England. First inexpensive edition in years. 392pp. 5⅜ × 8½. 25201-9 Pa. $8.95

THE RIME OF THE ANCIENT MARINER, Gustave Doré, Samuel Taylor Coleridge. Dramatic engravings considered by many to be his greatest work. The terrifying space of the open sea, the storms and whirlpools of an unknown ocean, the ice of Antarctica, more—all rendered in a powerful, chilling manner. Full text. 38 plates. 77pp. 9¼ × 12. 22305-1 Pa. $4.95

THE EXPEDITIONS OF ZEBULON MONTGOMERY PIKE, Zebulon Montgomery Pike. Fascinating firsthand accounts (1805–6) of exploration of Mississippi River, Indian wars, capture by Spanish dragoons, much more. 1,088pp. 5⅜ × 8½. 25254-X, 25255-8 Pa., Two-vol. set $25.90

A CONCISE HISTORY OF PHOTOGRAPHY: Third Revised Edition, Helmut Gernsheim. Best one-volume history—camera obscura, photochemistry, daguerreotypes, evolution of cameras, film, more. Also artistic aspects—landscape, portraits, fine art, etc. 281 black-and-white photographs. 26 in color. 176pp. 8⅜ × 11¼.
25128-4 Pa. $14.95

THE DORÉ BIBLE ILLUSTRATIONS, Gustave Doré. 241 detailed plates from the Bible: the Creation scenes, Adam and Eve, Flood, Babylon, battle sequences, life of Jesus, etc. Each plate is accompanied by the verses from the King James version of the Bible. 241pp. 9 × 12.
23004-X Pa. $9.95

WANDERINGS IN WEST AFRICA, Richard F. Burton. Great Victorian scholar/adventurer's invaluable descriptions of African tribal rituals, fetishism, culture, art, much more. Fascinating 19th-century account. 624pp. 5⅜ × 8½. 26890-X Pa. $12.95

HISTORIC HOMES OF THE AMERICAN PRESIDENTS, Second Revised Edition, Irvin Haas. Guide to homes occupied by every president from Washington to Bush. Visiting hours, travel routes, more. 175 photos. 160pp. 8¼ × 11.
26751-2 Pa. $9.95

THE HISTORY OF THE LEWIS AND CLARK EXPEDITION, Meriwether Lewis and William Clark, edited by Elliott Coues. Classic edition of Lewis and Clark's day-by-day journals that later became the basis for U.S. claims to Oregon and the West. Accurate and invaluable geographical, botanical, biological, meteorological and anthropological material. Total of 1,508pp. 5⅜ × 8½.
21268-8, 21269-6, 21270-X Pa., Three-vol. set $29.85

LANGUAGE, TRUTH AND LOGIC, Alfred J. Ayer. Famous, clear introduction to Vienna, Cambridge schools of Logical Positivism. Role of philosophy, elimination of metaphysics, nature of analysis, etc. 160pp. 5⅜ × 8½. (Available in U.S. and Canada only)
20010-8 Pa. $3.95

MATHEMATICS FOR THE NONMATHEMATICIAN, Morris Kline. Detailed, college-level treatment of mathematics in cultural and historical context, with numerous exercises. For liberal arts students. Preface. Recommended Reading Lists. Tables. Index. Numerous black-and-white figures. xvi + 641pp. 5⅜ × 8½.
24823-2 Pa. $11.95

HANDBOOK OF PICTORIAL SYMBOLS, Rudolph Modley. 3,250 signs and symbols, many systems in full; official or heavy commercial use. Arranged by subject. Most in Pictorial Archive series. 143pp. 8⅜ × 11. 23357-X Pa. $8.95

INCIDENTS OF TRAVEL IN YUCATAN, John L. Stephens. Classic (1843) exploration of jungles of Yucatan, looking for evidences of Maya civilization. Travel adventures, Mexican and Indian culture, etc. Total of 669pp. 5⅜ × 8½.
20926-1, 20927-X Pa., Two-vol. set $13.90

DEGAS: An Intimate Portrait, Ambroise Vollard. Charming, anecdotal memoir by famous art dealer of one of the greatest 19th-century French painters. 14 black-and-white illustrations. Introduction by Harold L. Van Doren. 96pp. 5⅜ × 8½.
25131-4 Pa. $4.95

PERSONAL NARRATIVE OF A PILGRIMAGE TO AL-MADINAH AND MECCAH, Richard F. Burton. Great travel classic by remarkably colorful personality. Burton, disguised as a Moroccan, visited sacred shrines of Islam, narrowly escaping death. 47 illustrations. 959pp. 5⅜ × 8½.
21217-3, 21218-1 Pa., Two-vol. set $19.90

PHRASE AND WORD ORIGINS, A. H. Holt. Entertaining, reliable, modern study of more than 1,200 colorful words, phrases, origins and histories. Much unexpected information. 254pp. 5⅜ × 8½.
20758-7 Pa. $5.95

THE RED THUMB MARK, R. Austin Freeman. In this first Dr. Thorndyke case, the great scientific detective draws fascinating conclusions from the nature of a single fingerprint. Exciting story, authentic science. 320pp. 5⅜ × 8½. (Available in U.S. only)
25210-8 Pa. $6.95

AN EGYPTIAN HIEROGLYPHIC DICTIONARY, E. A. Wallis Budge. Monumental work containing about 25,000 words or terms that occur in texts ranging from 3000 B.C. to 600 A.D. Each entry consists of a transliteration of the word, the word in hieroglyphs, and the meaning in English. 1,314pp. 6⅜ × 10.
23615-3, 23616-1 Pa., Two-vol. set $35.90

THE COMPLEAT STRATEGYST: Being a Primer on the Theory of Games of Strategy, J. D. Williams. Highly entertaining classic describes, with many illustrated examples, how to select best strategies in conflict situations. Prefaces. Appendices. xvi + 268pp. 5⅜ × 8½.
25101-2 Pa. $7.95

THE ROAD TO OZ, L. Frank Baum. Dorothy meets the Shaggy Man, little Button-Bright and the Rainbow's beautiful daughter in this delightful trip to the magical Land of Oz. 272pp. 5⅜ × 8.
25208-6 Pa. $5.95

POINT AND LINE TO PLANE, Wassily Kandinsky. Seminal exposition of role of point, line, other elements in nonobjective painting. Essential to understanding 20th-century art. 127 illustrations. 192pp. 6½ × 9¼.
23808-3 Pa. $5.95

LADY ANNA, Anthony Trollope. Moving chronicle of Countess Lovel's bitter struggle to win for herself and daughter Anna their rightful rank and fortune—perhaps at cost of sanity itself. 384pp. 5⅜ × 8½.
24669-8 Pa. $8.95

EGYPTIAN MAGIC, E. A. Wallis Budge. Sums up all that is known about magic in Ancient Egypt: the role of magic in controlling the gods, powerful amulets that warded off evil spirits, scarabs of immortality, use of wax images, formulas and spells, the secret name, much more. 253pp. 5⅜ × 8½.
22681-6 Pa. $4.95

THE DANCE OF SIVA, Ananda Coomaraswamy. Preeminent authority unfolds the vast metaphysic of India: the revelation of her art, conception of the universe, social organization, etc. 27 reproductions of art masterpieces. 192pp. 5⅜ × 8½.
24817-8 Pa. $6.95

CHRISTMAS CUSTOMS AND TRADITIONS, Clement A. Miles. Origin, evolution, significance of religious, secular practices. Caroling, gifts, yule logs, much more. Full, scholarly yet fascinating; non-sectarian. 400pp. 5⅜ × 8½.
23354-5 Pa. $7.95

THE HUMAN FIGURE IN MOTION, Eadweard Muybridge. More than 4,500 stopped-action photos, in action series, showing undraped men, women, children jumping, lying down, throwing, sitting, wrestling, carrying, etc. 390pp. 7⅞ × 10⅝.
20204-6 Cloth. $24.95

THE MAN WHO WAS THURSDAY, Gilbert Keith Chesterton. Witty, fast-paced novel about a club of anarchists in turn-of-the-century London. Brilliant social, religious, philosophical speculations. 128pp. 5⅜ × 8½.
25121-7 Pa. $3.95

A CÉZANNE SKETCHBOOK: Figures, Portraits, Landscapes and Still Lifes, Paul Cézanne. Great artist experiments with tonal effects, light, mass, other qualities in over 100 drawings. A revealing view of developing master painter, precursor of Cubism. 102 black-and-white illustrations. 144pp. 8¾ × 6⅝.
24790-2 Pa. $6.95

AN ENCYCLOPEDIA OF BATTLES: Accounts of Over 1,560 Battles from 1479 B.C. to the Present, David Eggenberger. Presents essential details of every major battle in recorded history, from the first battle of Megiddo in 1479 B.C. to Grenada in 1984. List of Battle Maps. New Appendix covering the years 1967–1984. Index. 99 illustrations. 544pp. 6½ × 9¼.
24913-1 Pa. $14.95

AN ETYMOLOGICAL DICTIONARY OF MODERN ENGLISH, Ernest Weekley. Richest, fullest work, by foremost British lexicographer. Detailed word histories. Inexhaustible. Total of 856pp. 6½ × 9¼.
21873-2, 21874-0 Pa., Two-vol. set $19.90

WEBSTER'S AMERICAN MILITARY BIOGRAPHIES, edited by Robert McHenry. Over 1,000 figures who shaped 3 centuries of American military history. Detailed biographies of Nathan Hale, Douglas MacArthur, Mary Hallaren, others. Chronologies of engagements, more. Introduction. Addenda. 1,033 entries in alphabetical order. xi + 548pp. 6½ × 9¼. (Available in U.S. only)
24758-9 Pa. $13.95

LIFE IN ANCIENT EGYPT, Adolf Erman. Detailed older account, with much not in more recent books: domestic life, religion, magic, medicine, commerce, and whatever else needed for complete picture. Many illustrations. 597pp. 5⅜ × 8½.
22632-8 Pa. $9.95

HISTORIC COSTUME IN PICTURES, Braun & Schneider. Over 1,450 costumed figures shown, covering a wide variety of peoples: kings, emperors, nobles, priests, servants, soldiers, scholars, townsfolk, peasants, merchants, courtiers, cavaliers, and more. 256pp. 8⅜ × 11¼.
23150-X Pa. $9.95

THE NOTEBOOKS OF LEONARDO DA VINCI, edited by J. P. Richter. Extracts from manuscripts reveal great genius; on painting, sculpture, anatomy, sciences, geography, etc. Both Italian and English. 186 ms. pages reproduced, plus 500 additional drawings, including studies for *Last Supper, Sforza* monument, etc. 860pp. 7⅞ × 10¾.
22572-0, 22573-9 Pa., Two-vol. set $35.90

THE ART NOUVEAU STYLE BOOK OF ALPHONSE MUCHA: All 72 Plates from "Documents Decoratifs" in Original Color, Alphonse Mucha. Rare copyright-free design portfolio by high priest of Art Nouveau. Jewelry, wallpaper, stained glass, furniture, figure studies, plant and animal motifs, etc. Only complete one-volume edition. 80pp. 9⅜ × 12¼. 24044-4 Pa. $10.95

ANIMALS: 1,419 Copyright-Free Illustrations of Mammals, Birds, Fish, Insects, Etc., edited by Jim Harter. Clear wood engravings present, in extremely lifelike poses, over 1,000 species of animals. One of the most extensive pictorial sourcebooks of its kind. Captions. Index. 284pp. 9 × 12. 23766-4 Pa. $10.95

OBELISTS FLY HIGH, C. Daly King. Masterpiece of American detective fiction, long out of print, involves murder on a 1935 transcontinental flight—"a very thrilling story"—NY Times. Unabridged and unaltered republication of the edition published by William Collins Sons & Co. Ltd., London, 1935. 288pp. 5⅜ × 8½. (Available in U.S. only) 25036-9 Pa. $5.95

VICTORIAN AND EDWARDIAN FASHION: A Photographic Survey, Alison Gernsheim. First fashion history completely illustrated by contemporary photographs. Full text plus 235 photos, 1840–1914, in which many celebrities appear. 240pp. 6½ × 9¼. 24205-6 Pa. $8.95

THE ART OF THE FRENCH ILLUSTRATED BOOK, 1700–1914, Gordon N. Ray. Over 630 superb book illustrations by Fragonard, Delacroix, Daumier, Doré, Grandville, Manet, Mucha, Steinlen, Toulouse-Lautrec and many others. Preface. Introduction. 633 halftones. Indices of artists, authors & titles, binders and provenances. Appendices. Bibliography. 608pp. 8⅜ × 11¼. 25086-5 Pa. $24.95

THE WONDERFUL WIZARD OF OZ, L. Frank Baum. Facsimile in full color of America's finest children's classic. 143 illustrations by W. W. Denslow. 267pp. 5⅜ × 8½. 20691-2 Pa. $7.95

FOLLOWING THE EQUATOR: A Journey Around the World, Mark Twain. Great writer's 1897 account of circumnavigating the globe by steamship. Ironic humor, keen observations, vivid and fascinating descriptions of exotic places. 197 illustrations. 720pp. 5⅜ × 8½. 26113-1 Pa. $15.95

THE FRIENDLY STARS, Martha Evans Martin & Donald Howard Menzel. Classic text marshalls the stars together in an engaging, nontechnical survey, presenting them as sources of beauty in night sky. 23 illustrations. Foreword. 2 star charts. Index. 147pp. 5⅜ × 8½. 21099-5 Pa. $3.95

FADS AND FALLACIES IN THE NAME OF SCIENCE, Martin Gardner. Fair, witty appraisal of cranks, quacks, and quackeries of science and pseudoscience: hollow earth, Velikovsky, orgone energy, Dianetics, flying saucers, Bridey Murphy, food and medical fads, etc. Revised, expanded In the Name of Science. "A very able and even-tempered presentation."—The New Yorker. 363pp. 5⅜ × 8. 20394-8 Pa. $6.95

ANCIENT EGYPT: Its Culture and History, J. E. Manchip White. From predynastics through Ptolemies: society, history, political structure, religion, daily life, literature, cultural heritage. 48 plates. 217pp. 5⅜ × 8½. 22548-8 Pa. $5.95

SIR HARRY HOTSPUR OF HUMBLETHWAITE, Anthony Trollope. Incisive, unconventional psychological study of a conflict between a wealthy baronet, his idealistic daughter, and their scapegrace cousin. The 1870 novel in its first inexpensive edition in years. 250pp. 5⅜ × 8½. 24953-0 Pa. $6.95

LASERS AND HOLOGRAPHY, Winston E. Kock. Sound introduction to burgeoning field, expanded (1981) for second edition. Wave patterns, coherence, lasers, diffraction, zone plates, properties of holograms, recent advances. 84 illustrations. 160pp. 5⅜ × 8¼. (Except in United Kingdom) 24041-X Pa. $4.95

INTRODUCTION TO ARTIFICIAL INTELLIGENCE: Second, Enlarged Edition, Philip C. Jackson, Jr. Comprehensive survey of artificial intelligence—the study of how machines (computers) can be made to act intelligently. Includes introductory and advanced material. Extensive notes updating the main text. 132 black-and-white illustrations. 512pp. 5⅜ × 8½. 24864-X Pa. $10.95

HISTORY OF INDIAN AND INDONESIAN ART, Ananda K. Coomaraswamy. Over 400 illustrations illuminate classic study of Indian art from earliest Harappa finds to early 20th century. Provides philosophical, religious and social insights. 304pp. 6⅜ × 9⅜. 25005-9 Pa. $11.95

THE GOLEM, Gustav Meyrink. Most famous supernatural novel in modern European literature, set in Ghetto of Old Prague around 1890. Compelling story of mystical experiences, strange transformations, profound terror. 13 black-and-white illustrations. 224pp. 5⅜ × 8½. 25025-3 Pa. $7.95

PICTORIAL ENCYCLOPEDIA OF HISTORIC ARCHITECTURAL PLANS, DETAILS AND ELEMENTS: With 1,880 Line Drawings of Arches, Domes, Doorways, Facades, Gables, Windows, etc., John Theodore Haneman. Sourcebook of inspiration for architects, designers, others. Bibliography. Captions. 141pp. 9 × 12.
24605-1 Pa. $8.95

BENCHLEY LOST AND FOUND, Robert Benchley. Finest humor from early 30s, about pet peeves, child psychologists, post office and others. Mostly unavailable elsewhere. 73 illustrations by Peter Arno and others. 183pp. 5⅜ × 8½.
22410-4 Pa. $4.95

ERTÉ GRAPHICS, Erté. Collection of striking color graphics: *Seasons, Alphabet, Numerals, Aces* and *Precious Stones.* 50 plates, including 4 on covers. 48pp. 9⅜ × 12¼.
23580-7 Pa. $7.95

THE JOURNAL OF HENRY D. THOREAU, edited by Bradford Torrey, F. H. Allen. Complete reprinting of 14 volumes, 1837–61, over two million words; the sourcebooks for *Walden,* etc. Definitive. All original sketches, plus 75 photographs. 1,804pp. 8½ × 12¼. 20312-3, 20313-1 Cloth., Two-vol. set $130.00

CASTLES: Their Construction and History, Sidney Toy. Traces castle development from ancient roots. Nearly 200 photographs and drawings illustrate moats, keeps, baileys, many other features. Caernarvon, Dover Castles, Hadrian's Wall, Tower of London, dozens more. 256pp. 5⅜ × 8¼. 24898-4 Pa. $7.95

AMERICAN CLIPPER SHIPS: 1833–1858, Octavius T. Howe & Frederick C. Matthews. Fully-illustrated, encyclopedic review of 352 clipper ships from the period of America's greatest maritime supremacy. Introduction. 109 halftones. 5 black-and-white line illustrations. Index. Total of 928pp. 5⅜ × 8½.
25115-2, 25116-0 Pa., Two-vol. set $21.90

TOWARDS A NEW ARCHITECTURE, Le Corbusier. Pioneering manifesto by great architect, near legendary founder of "International School." Technical and aesthetic theories, views on industry, economics, relation of form to function, "mass-production spirit," much more. Profusely illustrated. Unabridged translation of 13th French edition. Introduction by Frederick Etchells. 320pp. 6⅛ × 9¼. (Available in U.S. only)
25023-7 Pa. $8.95

THE BOOK OF KELLS, edited by Blanche Cirker. Inexpensive collection of 32 full-color, full-page plates from the greatest illuminated manuscript of the Middle Ages, painstakingly reproduced from rare facsimile edition. Publisher's Note. Captions. 32pp. 9⅜ × 12¼. (Available in U.S. only)
24345-1 Pa. $5.95

BEST SCIENCE FICTION STORIES OF H. G. WELLS, H. G. Wells. Full novel *The Invisible Man*, plus 17 short stories: "The Crystal Egg," "Aepyornis Island," "The Strange Orchid," etc. 303pp. 5⅜ × 8½. (Available in U.S. only)
21531-8 Pa. $6.95

AMERICAN SAILING SHIPS: Their Plans and History, Charles G. Davis. Photos, construction details of schooners, frigates, clippers, other sailcraft of 18th to early 20th centuries—plus entertaining discourse on design, rigging, nautical lore, much more. 137 black-and-white illustrations. 240pp. 6⅛ × 9¼.
24658-2 Pa. $6.95

ENTERTAINING MATHEMATICAL PUZZLES, Martin Gardner. Selection of author's favorite conundrums involving arithmetic, money, speed, etc., with lively commentary. Complete solutions. 112pp. 5⅜ × 8½.
25211-6 Pa. $3.95

THE WILL TO BELIEVE, HUMAN IMMORTALITY, William James. Two books bound together. Effect of irrational on logical, and arguments for human immortality. 402pp. 5⅜ × 8½.
20291-7 Pa. $8.95

THE HAUNTED MONASTERY and THE CHINESE MAZE MURDERS, Robert Van Gulik. 2 full novels by Van Gulik continue adventures of Judge Dee and his companions. An evil Taoist monastery, seemingly supernatural events; overgrown topiary maze that hides strange crimes. Set in 7th-century China. 27 illustrations. 328pp. 5⅜ × 8½.
23502-5 Pa. $6.95

CELEBRATED CASES OF JUDGE DEE (DEE GOONG AN), translated by Robert Van Gulik. Authentic 18th-century Chinese detective novel; Dee and associates solve three interlocked cases. Led to Van Gulik's own stories with same characters. Extensive introduction. 9 illustrations. 237pp. 5⅜ × 8½.
23337-5 Pa. $5.95

Prices subject to change without notice.

Available at your book dealer or write for free catalog to Dept. GI, Dover Publications, Inc., 31 East 2nd St., Mineola, N.Y. 11501. Dover publishes more than 400 books each year on science, elementary and advanced mathematics, biology, music, art, literary history, social sciences and other areas.